research in conservation

The Getty Conservation Institute

T0133256

Biodeterioration of Stone in Tropical Environments

An Overview

Rakesh Kumar
Anuradha V. Kumar

1999

Neville Agnew, *Series Editor*
Dinah Berland, *Managing Editor*
Suzanne Sherman-Aboulfadl, *Manuscript Editor*
Anita Keys, *Production Coordinator*
Hespenheide Design, *Designer*

Printed in the United States of America
10 9 8 7 6 5 4 3 2 1

The Getty Conservation Institute

The Getty Conservation Institute works internationally to further the appreciation and preservation of the world's cultural heritage for the enrichment and use of present and future generations. The Institute is an operating program of the J. Paul Getty Trust.

Research in Conservation

The Research in Conservation reference series presents the findings of research conducted by the Getty Conservation Institute and its individual and institutional research partners, as well as state-of-the-art reviews of conservation literature. Each volume covers a topic of current interest to conservators and conservation scientists. Other volumes in the Research in Conservation series include *Inert Gases in the Control of Museum Insect Pests* (Selwitz and Maekawa 1998); *Oxygen-Free Museum Cases* (Maekawa 1998); *Stone Conservation: An Overview of Current Research* (Price 1996); *Accelerated Aging: Photochemical and Thermals Aspects* (Feller 1994); *Airborne Particles in Museums* (Nazaroff, Ligocki, et al. 1993); *Epoxy Resins in Stone Consolidation* (Selwitz 1992); *Evaluation of Cellulose Ethers for Conservation* (Feller and Wilt 1990); *Cellulose Nitrate in Conservation* (Selwitz 1988); and *Statistical Analysis in Art Conservation Research* (Reedy and Reedy 1988).

ISBN 0-89236-550-1

Library of Congress Cataloging-in-Publication Data

Kumar, Rakesh, 1962–
 Biodeterioration of stone in tropical environments : an overview / Rakesh
 Kumar, Anuradha V. Kumar.
 p. cm.—(Research in conservation)
 Includes bibliographical references and index.
 ISBN 0-89236-550-1 (pbk.)
 1. Stone—Tropics—Deterioration. 2. Building stones—Tropics—
 Deterioration. 3. Monuments—Conservation and restoration—Tropics.
 4. Art—Conservation and restoration—Tropics. I. Kumar, Anuradha V.,
 1965– . II. Title. III. Series.
 TA427.K86 1999 98–49800
 620.1′3223—dc21 CIP

Contents

Foreword

Stone has been one of the most intensely studied materials in conservation. The problem of understanding the deterioration of stone is compounded by the large range of types with different mineralogical and physical characteristics and their varying weathering responses under different climatic and environmental conditions.

The Getty Conservation Institute has been engaged in studying stone for several years. Two previous volumes in the Research in Conservation series have also addressed this subject: *Epoxy Resins in Stone Consolidation* by Charles Selwitz (1992) and *Stone Conservation: An Overview of Current Research* by C. A. Price (1996). The present volume reviews research undertaken in tropical regions with climates that vary from wet to dry.

Many agents contribute to the deterioration of stone monuments, buildings, and other objects of cultural value. This publication concentrates on the action of biodeteriogens from bacteria to algae to higher plants. Preventive and remedial methods are surveyed, as are a selection of chemical treatments. In addition, avenues of research are opened for further investigation.

While at the Getty Conservation Institute, Rakesh Kumar and Anuradha V. Kumar undertook the research for this review of the literature. We hope their clear presentation of the issues will be of value to professionals involved in the field of stone conservation. As always, we welcome readers' comments and observations.

Neville Agnew
The Getty Conservation Institute

Introduction

Biodeterioration may be defined as any undesirable change in the properties of a material caused by the vital activities of living organisms. This definition distinguishes biodeterioration from fields of study such as corrosion and wear of materials that relate to undesirable changes in the properties of a material brought about by chemical, mechanical, and physical influences.

Biodeterioration of stone monuments and buildings is a well-recognized problem in tropical regions, where environmental factors such as high temperatures, high relative humidity levels, and heavy rainfall favor the growth and sustenance of a wide variety of living organisms on stone surfaces.

There is a general consensus among conservators and conservation scientists that the alteration of stone monuments due to living organisms is usually indicative of an advanced state of deterioration predetermined by physical and chemical parameters. In other words, except in the case of higher plants, which have been known to cause direct and dramatic physical damage to stone structures, the initial deterioration of stone exposed to the outdoor environment and action of agents such as rain, wind, sunlight, and pollution may be due to physical and chemical processes. These agents cause an increase in the surface area of stone by the formation of micro- and macrofissures or formation of encrustations. When the surface of the monument has undergone this process of alteration, living organisms begin to colonize the area.

Biodeterioration of stone, hence, cannot be considered as an isolated phenomenon. It generally occurs with other physical, chemical, or physicochemical deterioration processes. Its study, therefore, is complex and interdisciplinary and takes into account the numerous interrelationships among various biological populations and between these populations and the other processes occurring in the surrounding environment.

Aims and Scope of This Volume

This publication aims at establishing the continued need for focused scientific investigations on the subject of biodeterioration of stone in tropical regions through discussions on the extent of the problem, available preventive and remedial treatments, and current research. It outlines

possible directions for future research that could significantly expand knowledge in the field.

To reduce the vast scope of the subject, this volume reviews only literature on microorganisms and lower and higher plants. It must, however, be emphasized that biodeterioration caused by animals, including humans, is of considerable importance and must be addressed elsewhere.

To better understand the extent of the problem, it has been necessary to review literature on relevant primary research on the mechanisms of biodeterioration that have not necessarily been conducted in tropical regions. On the other hand, the review and analysis of the available literature on remedial and preventive measures primarily focuses on tropical regions. However, some references to such measures in other climatic regions and associated laboratory studies have been included to highlight their overall effectiveness and limitations.

General Outline

The ecological aspects of biodeterioration and the environmental conditions of the tropics are discussed in the first chapter of this publication. This chapter also describes the phenomenon of biological alterations and available tools and techniques for identifying biological agents and associated deterioration on the stone substrate.

The extent and type of biological degradation induced in different types of stone depend on the type of organisms found thereon. Evidence and quantitative data establishing the presence of a large variety of microorganisms on stone monuments in tropical regions and their contribution to the destruction of stone have been presented by a number of authors. The information contained therein has been synthesized in the second chapter to provide better understanding of the mode of action of various microorganisms, as well as of lower and higher plants, and the factors conducive to their growth on stone.

The extent to which these organisms are involved in the stone decay process has been increasingly clarified and discussed in the literature. The second chapter also provides a review of this literature and a concise summary of the various mechanisms and symptoms of biodeterioration of stone including, where known, the relative susceptibility of different types of stone.

The treatment of stone designed to minimize biodeterioration follows two general courses of action: preventive measures aimed at forestalling the possibilities of destruction, and control measures that can be undertaken once infestation has already set in. Review of the literature on both preventive and remedial measures has been included in the third chapter. Preventive measures include regular maintenance procedures, design strategies/approaches, and chemical conservation treatments that prevent retention of moisture and humidity in outdoor monuments and consequently discourage biological growth. Remedial measures include physical as well as chemical measures that directly kill and inhibit bio-

logical growth on stone. Advantages and limitations of each of these measures have been mentioned wherever references were available.

An enormous variety of chemical treatments are available today for the prevention and destruction of biological infestation. These available treatments have been considered in the fourth chapter with regard to their apparent activity, mode of action, toxicity, risk of environmental pollution, and compatibility with stone substrates and other conservation treatments on stone monuments in tropical regions.

This publication concludes with a chapter on possible directions for future investigations based on the status of current research in tropical regions and the critical review of available literature.

Authors' Acknowledgments

We wish to thank Neville Agnew, Alberto Tagle, Patricia Martinez, R. K. Sharma, and Martha Demas for their encouragement, advice, and strong support of our initial thoughts on reviewing the status of research on biodeterioration of stone monuments in tropical regions.

We are especially grateful to William S. Ginell for his continuous support and review of this work since its inception, and to Ralph Mitchell of Harvard University, Cambridge, Massachusetts; and Giuila Caneva of Universitá Degli Studi "Roma Tre," Rome, Italy, for their invaluable advice and their constructive and critical review of the manuscript.

We would also like to thank Jackie Zak for assistance with the extensive bibliographic search, and Carol Cressler, Jill Markman, and Valerie Greathouse for tracking down and obtaining every obscure reference. Sincere appreciation is also extended to the editorial professionals who helped to bring this book to light: Dinah Berland, the volume's managing editor; Suzanne Sherman-Aboulfadl, scientific copy editor; Scott Patrick Wagner, reference editor and electronic file manager; and Anita Keys, production coordinator for Getty Trust Publication Services.

Chapter 1

General Aspects of Biodeterioration in Tropical Regions

Characteristics of Tropical Regions

The term *humid tropics* collectively refers to those parts of the world that lie between the Tropic of Cancer (23.5° N) and the Tropic of Capricorn (23.5° S). This region occupies more than one-third of the earth's total surface (about 20% of the land area and just over 40% of the oceans), which makes it the most extensive climatic area on earth.

For most geographical and ecological purposes, the above definition is too rigid and does not adequately delimit regions with distinctive physical or biological characteristics. Numerous other schemes of defining or subdividing the tropics have therefore been proposed by climatologists, geomorphologists, and biologists. These, however, are also problematic, as each scientific discipline has different requirements for developing a classification system. For instance, botanists require the tropics to be distinguished by particular vegetation assemblages, climatologists perceive the tropics as areas where specific atmospheric conditions prevail, and geomorphologists prefer that boundaries describe areas where physical processes take place with a certain intensity or magnitude. It is unusual for boundaries of various classification systems to correspond exactly.

Some classifications are directly based on climatic parameters such as temperature and rainfall (Köppen 1936; Garnier 1958; Gourou 1966; Tricart 1972). Köppen's classification is the most widely recognized and forms the basis from which most other classifications (Mink 1983) have developed.

The modified Köppen's system recognizes three major divisions of humid tropical climates on the basis of rainfall amounts and seasonal patterns: the wet tropical, monsoon tropical, and tropical wet-and-dry (or wet-dry). Some authors include an additional division of subhumid climates to encompass those areas (approximately 30° N to 30° S) within which geomorphological processes, especially weathering patterns, are very similar to those of humid tropics proper (Tricart 1972; Akin 1991).

Latitude is a major factor affecting the climatic conditions of a region through its control on the amount of solar radiation received. The tropics receive large amounts of solar radiation throughout the year. As a result, seasonal fluctuations in temperature are minimal, and there is no distinct or true winter season (Reading, Thompson, and Millington 1995).

The thermal requirement for a tropical climate is considered to be an average mean temperature above 18 °C for the coldest month, except for cooler tropical highlands, which make up around 25% of land surface within the tropics. In common with the tropical lowlands, these tropical highlands also receive high degrees of solar radiation and do not have a thermally depressed winter season.

Since insolation and temperature are relatively uniform at any tropical site, differences in the amount and temporal distribution of available water, principally in the form of precipitation, largely account for regional and seasonal differences in tropical regions. It is therefore generally accepted that moisture is a valid criterion for differentiating among types of tropics.

Wet tropical climates

A major part of the area characterized by wet tropical climates lies within 10° to 15° of the equator, where the equatorial low-pressure zone dominates weather patterns. Conditions within the wet tropical climate are always warm and moist. At lower elevations, the monthly mean temperatures lie between 27 °C and 30 °C, with an annual range of less than 3 °C between the coolest and the warmest months. Mean annual rainfall usually exceeds 1500 mm, with no month receiving less than an average of 60 mm. Although by this definition there is no dry season, there are almost always rainy and less rainy seasons. Tropical rainforests occupy large areas of land within this climate, which has also been designated as "tropical rainforest climate" by Köppen and many others in earlier classification systems used from the 1930s to the 1970s.

The wet tropical climate is most widespread in three areas: the Amazon Basin and adjacent parts of South America; central and western Africa, particularly in parts of the Zaire (formerly Congo) Basin; and the numerous islands and peninsulas of Southeast Asia.

Monsoon tropical climates

Poleward of the core of the wet tropical climatic areas, within 10°–20° of the equator, particularly on the eastern margins of the continental masses, are climates with average annual precipitation equal to or exceeding that of the wet tropical climates. Unlike the wet tropical climates, however, these areas have a well-defined short dry season. Because of the heavy seasonal rainfall and the relatively short dry season, the soil remains moist enough throughout the year to support the growth of evergreen rainforests. Average precipitation for the driest month is less than 60 mm, but the annual mean rainfall is more than 2500 mm, regardless of the severity of the dry season. Monsoon tropical areas exist on the coastal margins of northeastern South America, Central America, West Africa, and Southeast Asia.

Tropical wet-and-dry climates

Lying poleward of the core of the wet tropical climates, within 10°–20° of the equator, is a broad area in which the annual precipitation average is between 1500 mm and 760 mm and where there is a severe dry season.

Rainfall is concentrated in the high-sun, or "summer," season; and the dry season coincides with the low-sun, or "winter," season. The driest month averages precipitation of less than 600 mm, although in many areas the dry season is almost absolute.

The wet-dry tropics constitute a broad transition zone between wet equatorial areas and the great low-latitude steppes and deserts. High-sun ("summer") rainfall brings a rainy season, during which conditions are like those of the wet tropical areas, whereas the drought of the low-sun ("winter") season is reminiscent of the deserts and steppes. The annual pattern of rainfall results from shifts in the semi-permanent belts of wind and barometric pressure. Essentially, these areas are dominated by the doldrums of the rainy season and the great subtropical highs, and dry margins, of the trade winds during the dry season.

Major areas of tropical wet-and-dry climate exist in Africa, South America, Southeast Asia, and Australia, where tropical savannas are an important component of natural vegetation. Savannas are a mixture of grass and trees, the basis for the designation of "tropical savanna climate" in earlier terminology.

Subhumid climates

Subhumid climates are transitional climates between the winterless tropics and temperate regions that have a severe winter climate. They have a definite but mild winter, with temperatures of the coolest month averaging below 18 °C but above 0 °C. Subhumid climates occupy the east coasts of continents between 20° and 30° latitudes. Major areas of this climate extend considerable distances inland from the coasts. Eastern coastal location places these climates on the western, or moist, side of the subtropical highs, where monsoonal circulation causes an onshore flow of moist, tropical maritime air during summer months. In winter, the shift toward the equator of middle-latitude cyclonic storm tracks in the westerlies generally brings some precipitation in some of these regions. This pattern of atmospheric circulation assures mild, moist, or relatively dry winters and hot, humid summers. Southeastern United States, southeastern South America, and eastern Australia have no dry season, whereas margins of the wet-dry tropics in Southeast Asia, including northern India and interior of China, have a distinct dry winter.

Ecological Aspects of Biodeterioration

The development of specific biological species on a particular stone surface is determined by the nature and properties of the stone (mineral constituents, pH, relative percentage of various minerals, salinity, moisture content, texture). It also depends on certain environmental factors (temperature, relative humidity, light conditions, atmospheric pollution levels, wind, rainfall). In other words, the response of living organisms to a potentially colonizable surface depends on the ecological and physiological requirements of the biological species involved (Caneva and Salvadori 1988).

Broadly speaking, all living organisms can be classified as autotrophs and heterotrophs on the basis of their nutritional requirements (Table 1.1). For all autotrophic organisms, inorganic surface constituents represent potential nutritive substances and are important factors that condition their growth. On the other hand, heterotrophic organisms grow only when organic matter is present on the surface. Most organisms, except xerophilous species, prefer surfaces with a high moisture content.

As already mentioned, environmental factors in tropical regions, such as high temperatures and high relative humidity levels, are favorable for the sustenance of most organisms. The presence of sunlight is essential for photosynthetic organisms and provides the necessary energy for biosynthesis. Chemosynthetic organisms can survive without sunlight. They derive energy for biosynthesis from chemical reactions (Krumbein 1968; Stanier, Doudoroff, and Adelberg 1970; Meincke et al. [1988]; Caneva and Salvadori 1988; Caneva, Nugari, and Salvadori 1991; Jain, Mishra, and Singh 1993; Tiano 1993). In most instances,

Table 1.1 Classification of organisms based on their nutritional requirements

Nutritional Category	Energy Source	Carbon Source	Electron Donors	Electron Acceptors	Groups of Organisms
Photoautotrophs or photolithotrophs	Sunlight (photosynthetic organisms)	CO_2	Water	Oxygen Organics	**Aerobic organisms:** Cyanobacteria Algae (Bacillariophyta or Diatoms) Algae (Chlorophyta) Lichens Mosses and liverworts Higher plants
Chemoautotrophs or chemolithotrophs	Redox reactions (chemosynthetic organisms)	CO_2	H_2 Fe^{2+} NH_4^+ NO_2^- S, $S_2O_3^{2-}$	Oxygen	**Aerobic organisms:** Hydrogen bacteria Iron bacteria Nitrifying bacteria Sulfur-oxidizing bacteria
Photoheterotrophs or photoorganotrophs	Sunlight (photosynthetic organisms)	Organics	Organics	Oxygen	**Aerobic organisms:** Photosynthetic bacteria Some algae
			H_2S H_2	Organics	**Anaerobic organisms:** Green and purple sulfur bacteria Purple nonsulfur bacteria
Chemoheterotrophs or chemoorganotrophs	Redox reactions (chemosynthetic organisms)			Oxygen	**Aerobic organisms:** Actinomycetes Animals Fungi Respiratory bacteria
		Organics	Organics S, $S_2O_3^{2-}$ H_2S	Organics NO_3^- SO_4^{2-}	**Anaerobic organisms:** Fermentative bacteria Denitrifying bacteria Sulfur-reducing bacteria

See Glossary for definitions of terms.

atmospheric pollutants, especially SO_2 and NO_x, have been found to be detrimental to the growth of biodeteriogens (Rao and Le Blanc 1966; Levitt 1972; Nieoboer et al. 1976; Heck and Brandt 1977). On the other hand, soot and other organic pollutants can help maintain the growth and activity of certain heterotrophic organisms (Saiz-Jimenez 1994).

Identification of Biodeteriogens and Their Activity

Information on the main morphological and physiological characteristics of biological agencies is available in a plethora of journals and books on biology, microbiology, and other related subjects. An understanding of these characteristics is required to identify accurately the biological species that have established themselves on the surface of, and sometimes within, the building stone of ancient monuments. However, to understand the role of these biological agencies in the stone-decay process, it is not only essential to establish the exact characterization, both qualitatively and quantitatively, of all the organisms active on the stone, but it is also important to assess the cause-effect link of biodeteriogenic action of a specific identified biological agent. Knowledge of the types of species present and their activity is valuable to conservators and conservation scientists, as it has been adequately established that the type of biodeterioration depends on the type of organism involved (Caneva, Nugari, and Salvadori 1991; Jain, Mishra and Singh 1993; Tiano 1993). Such knowledge is therefore critical to the appropriate choice of preventive and eradication methods.

Characterization of biodeteriogens
Lichens, mosses, and liverworts, as well as higher plants, are easily identified using visual observations in the field and in the laboratory through microscopic diagnostic methods. Examination of morphological and physiological characteristics—such as the thallus and reproductive elements of the lichens and bryophytes; and leaves, flowers, and fruits of higher plants—provides clues for the accurate identification and classification of a species (Caneva, Nugari, and Salvadori 1991). On the other hand, organisms such as bacteria, actinomycetes, fungi, and algae are not as easily identifiable through direct visual examination. Their study involves the isolation and characterization of the active microbial agents in a field sample, re-creation of geomicrobial process under laboratory conditions using an enriched or pure culture from the field sample, and characterization of the reaction mechanisms of active microbial agents (Ehrlich 1981).

Only rarely can visual observation of the microbial flora be made in situ. In most instances, some basic qualitative information about microorganisms on stone surfaces has been obtained from optical, electron, and stereo microscopic examination of samples collected from monuments. Fluorescence microscopy used in conjunction with staining with fluorescent dyes and fluorescent antibodies (Ehrlich 1981) or scanning electron microscopy (Sieburth 1975; Golubic, Brunet, and Le Campion 1970; Friedmann 1971; Bassi and Giacobini 1973; Koestler et al. 1985;

Giacobini et al. 1988) has proven to be very useful for identifying microorganisms and their activity. Differential interference contrast optics and epifluorescence have also been used for in situ observations of biodeterioration (Fliermans and Schmidt 1977; Koestler et al. 1985).

Microorganisms may also be detected in field samples by enrichment culture techniques (with mineral culture media). Microbes, especially bacteria, actinomycetes, algae, and fungi from field samples, may be cultured aerobically on a variety of media, with and without prior enrichment, or anaerobically cultivated in liquid and solid media (e.g., agar-shake cultures). Such culture methods may fail to detect all organisms present in the field sample because of the culture media's nutritional insufficiency.

Different organisms may be isolated from field samples using standard microbiological techniques such as staining (Curri and Paleni 1981) and enzymatic testing (Curri and Paleni 1976; Warscheid, Petersen, and Krumbein 1990). Isolated colonies of microorganisms grown in the culture can then be investigated by optical and electron microscopy.

The size of the microbial population in a field sample may be determined visually and by culturing. In situ visual estimation of most microbes usually requires staining with a fluorescent dye or fluorescent antibody followed by fluorescence microscopy (Ehrlich 1981).

Cultural estimation of specific microbes in a field sample involves dislodging organisms from the stone surface by agitation, vortexing, or exposure to ultrasound (sonication), and then suspending them in a suitable liquid medium. Quantitative information is usually obtained from the suspension with count methods, including plate counts and most-probable-number methods (Tiano, Tomaselli, and Orlando 1989).

An alternative approach, when the cells to be enumerated are firmly attached to the particles, is to dissolve the particles in question. If the treatment is mild enough, the freed microbial cells, although killed, may remain intact and may thus be countable by direct microscopic enumeration. If the dissolution process destroys cells, an indirect estimation such as the measurement of cell nitrogen may be performed. In the case of a mixed population, however, cell nitrogen measurement cannot readily be converted to cell numbers because different microbes do not necessarily contain similar concentrations of cell nitrogen. Even in a pure culture, the nitrogen concentration per cell may vary depending on age and nutritional conditions.

Another indirect method of microbial enumeration involves the extraction of adenosine triphosphate (ATP) from microbial cells on the field samples (Ehrlich 1981). Since different kinds of microorganisms harbor different amounts of ATP, the ATP measurement, like the cell nitrogen measurement, cannot be easily converted to cell number when dealing with a mixed population.

Despite the shortcomings of enumerative methods, it is possible to obtain valuable information from such procedures if the investigator (1) has an understanding of the nature of the sample to be tested, (2) gives attention and care to the preparation of the sample, (3) utilizes methodology appropriate to the nature of the sample and types of micro-

organisms to be enumerated, (4) includes calibration standards when required and/or possible, (5) provides sufficient replicates to obtain statistically precise, if not accurate, results, and (6) realizes that numerical results are only indicative (Gavin and Cummings 1972).

Study of microbial activity

Studies of geomicrobial phenomena require ingenuity in applying standard microbiological, chemical, and physical techniques and often require collaboration among microbiologists, geochemists, mineralogists and other specialists to unravel the problem. With such interdisciplinary cooperation, it is possible today to strongly suggest, and in some cases quantitatively determine, that microbes destroy rocks and that this process is faster than exclusively physical-chemical destruction (Warscheid 1990; Sterflinger 1995; Diakumaku 1996; Krumbein et al. 1996).

Several scientific techniques have been used recently in the study of biodeterioration (Bassi and Giocobini 1973; Krumbein and Altmann 1973; Benassi et al. 1976a, 1976b; Galizzi, Ferrari, and Ginetti 1976; Curri and Paleni 1981; Salvadori and Zitelli 1981; Bell 1984; Koestler et al. 1985; Bech-Anderson 1986; Eckhardt [1988]; Gugliandolo and Maugeri [1988]; Kuroczkin et al. [1988]; Lazzarini and Salvadori 1989). These methods include microscopy, such as scanning electron microscopy (SEM), polarized light microscopy (PLM), and fluorescence microscopy; qualitative identification of organic and inorganic chemical species using techniques such as energy-dispersive spectroscopy (EDS), X-ray diffraction (XRD), thin-layer chromatography (TLC), gas chromatography–mass spectrometry (GC-MS), and infrared spectroscopy (IR); and adaptation of biochemical culturing, counting, and histochemical techniques used to quantify, identify, and establish the presence of biological organisms. In situ nondestructive techniques such as videomicroscopy, remission spectroscopy, and respiration bell-jar methods, have been found useful for the investigation of biodeterioration processes (Becker et al. 1994).

Microbial activity that occurred in the geological past may under certain circumstances be identified indirectly using isotope fractionation techniques. Certain prokaryotic and eukaryotic microbes can distinguish between stable isotopes of elements such as sulfur, carbon, oxygen, and nitrogen. The microbes, especially under conditions of limited growth, prefer to metabolize substrates containing the lighter isotopes of these elements. Consequently, the products of metabolism will be enriched in lighter isotopes. In practice, isotope fractionation is measured by determining isotopic ratios by mass spectrometry and then calculating the amount of isotope enrichment. With this technique it can be determined whether mineral deposit is biogenic or abiogenic (Ehrlich 1981).

Traditional microbiological procedures for detecting microbial activity are highly specialized, time consuming, or unsuitable for use by conservators. A simple method of measuring microbial activity using calorimetric assays of fluorescein diacetate (FDA) and 2-(4-iodophenyl)-3-(4-nitrophenyl)-5-phenyl tetrazolium chloride (INT) helps evaluate the potential risk to the integrity of the stone by microbial populations

(Harvey and Young 1980; Bitton and Koopman 1982; Schnurer and Rosswall 1982; Quinn 1984; King and Parker 1988; Tayler and May 1995). FDA measures general enzymatic activity, whereas INT is a measure of metabolic activity. However, FDA offers obvious advantages over INT because of its greater sensitivity and rapid reaction rate with natural stone and its ability to produce measurable positive reactions in less than an hour of incubation. Comparisons between amounts of FDA cleaved and INT reduced for pure cultures of bacteria and natural mixed microbial populations on stone also indicate that it is possible to use FDA as an indirect measure of metabolic activity. The simplicity of the method makes it suitable for nonscientific personnel with minimal scientific equipment to identify stone at risk from active microbial populations. However, enzymes released by damaged, inactive cells may lead researchers to overestimate the activity of the active population (Tayler and May 1995).

The modified assay of dehydrogenase activity (DHA) is useful in the study of microbial influence on the decay of stone (Warscheid, Petersen, and Krumbein 1990). The enzyme test complements the usual microbiological examination procedures, providing a rapid quantification of the actual metabolic activity of the microbial communities colonizing the surface layers of the stone in historic monuments. The test can also be used to assess the influence of different nutrient compounds on microorganism metabolism. Thus, potential biodeterioration activity due to accumulation of biogenic substrate or air pollutants on the stone surface, as well as the application of stone preservative, can be easily assessed. In addition to the quantification of microbial activity, a red-colored indicator for DHA facilitates the examination of the spatial distribution of microorganisms over the rock profile from the surface to deeper and less infected layers of building stone.

Phenomenology of Biological Alterations

The ability to recognize the nature of biological alterations on stone is of practical importance to conservators. To recognize a biological attack and distinguish it from other causes requires a typical morphology of the alteration. Recognizability depends upon the experience of the person observing the phenomenon and upon the level of taxonomical accuracy required. In many cases an unspecialized person can affirm whether the cause of deterioration is biological. Obviously, macroorganisms and higher plants are easier to recognize than microorganisms because their dimensions permit observation with the naked eye. Still, algal patinas, mosses, and sometimes lichens are frequently confused with each other by the nonbiologist. The detailed systematic information (order, class, family, genus, and species) that is necessary for selecting and performing the correct preventive or control measures can be obtained only with specific analyses. The phenomenology of alteration varies according to the biological species involved, the nature of the surface, the climate, and often the period of the year (Table 1.2).

Table 1.2 Phenomenology of biological alterations in stone monuments

Organism	Alteration
Autotrophic bacteria	Black crust, black-brown patinas, exfoliation, powdering
Heterotrophic bacteria	Black crust, black patinas, exfoliation, color change
Actinomycetes	Whitish gray powder, patinas, white efflorescence
Cyanobacteria	Patinas and sheets of various colors and consistency
Fungi	Colored stains and patches, exfoliation, pitting
Algae	Patinas and sheets of various colors and consistency
Lichens	Crusts, patches, and pitting
Mosses and liverworts	Discoloration, green-gray patches
Higher plants	Cracks, collapse, detachment of materials

Chapter 2

Biodeteriogens: Characteristics and Biodeterioration Mechanisms

A *biodeteriogen* is an organism that is capable of causing biodeterioration. A wide variety of biodeteriogens have been identified on stone monuments in tropical environments due to the particularly favorable environmental conditions (high relative humidity, high temperatures, and heavy rainfall) in those regions. These organisms can cause direct or indirect damage to many kinds of stone. In some cases, the ability to cause serious damage has been well established; in others, it remains conjectural.

In the past, much of the primary research on the mechanisms of biodeterioration has not been conducted in tropical climates. However, these studies are useful because they form the basis of much of our understanding of the basic mechanisms of biodeterioration (Kauffmann 1952; Henderson and Duff 1963; Webley, Henderson, and Taylor 1963; Stambolov and Van Asperen De Boer 1967; Hueck–van der Plas 1968; Pochon and Jaton 1968; Silverman and Munoz 1970; Schaffer 1972; Krumbein and Jens 1981; Strzelczyk 1981; Krumbein 1983; Eckhardt 1985; Krumbein, Grote, and Petersen 1987; Krumbein [1988]; Petersen, Grote, and Krumbein [1988]; Seaward et al. 1989; Leznicka et al. 1991; Jain, Mishra, and Singh 1993; Tiano 1993).

Although the deterioration of stone monuments in tropical regions due to the action of biodeteriogens has long been recognized, only in the past few years has this subject received attention by conservators and conservation scientists. The mechanical and structural damage caused by the roots of higher plants and the discoloration produced by microorganisms and lower plants are obvious indications of a biogenic problem. It is the metabolic (Lewis, May, and Bravery 1988) and mechanical effects (Griffin, Indictor, and Koestler 1991) of microorganisms that are more difficult to appreciate and separate from purely physical and chemical phenomena. The problem remains one of establishing whether such growth is a primary or secondary cause of damage. Moreover, the extent of overall damage that can be attributed specifically to biodeteriogens is a matter of controversy since much of biodeterioration occurs in conjunction with other physical and chemical decay processes.

Biodeterioration of stone monuments in the tropics may be classified broadly into three categories: biophysical, biochemical, and aesthetic deterioration (Allsopp and Seal 1986; Caneva, Nugari, and Salvadori 1991; Jain, Mishra, and Singh 1993). Depending on the bio-

deteriogens, the nature of stone, and environmental conditions, these processes may occur separately or simultaneously.

Biophysical deterioration of stone may occur due to pressure exerted on the surrounding surface material during the growth or movement of an organism or its parts. Attachment devices, such as hyphae and extensive root systems, penetrate deeply into the stone through pre-existing cracks or crevices, causing stresses that lead to physical damage of surrounding stone material.

Fragmentation may also occur due to periodic loosening of attachment devices during repeated wet and dry cycles. Once the stone is damaged as a result of biophysical processes, it becomes more susceptible to other deterioration factors, particularly biochemical.

Biochemical deterioration resulting from assimilatory processes, where the organism uses the stone surface as a source of nutrition, is probably more easily understood than deterioration resulting from dissimilatory processes, where the organism produces a variety of metabolites that react chemically with the stone surface (Seshadri and Subramanian 1949; Mortland, Lawton, and Uehara 1956; Voute 1969; Hellebust 1974; Williams and Rudolph 1974; Strzelczyk 1981; Gayathri 1982; Bell 1984; Arai 1985; Caneva and Altieri [1988]; Tandon 1991; Saxena, Jain, and Singh 1991; Jain, Mishra, and Singh 1993).

Most autotrophic microorganisms and plants produce acids that can attack and dissolve some types of stone (Keller and Fredrickson 1952; Caneva and Altieri [1988], Caneva, Nugari, and Salvadori 1991). Heterotrophic organisms also produce organic acids that are capable of dissolving stone with the leaching of cations (Lewis et al. 1987; Lewis, May, and Greenwood [1988]; Jain, Saxena, and Singh 1991; Griffin, Indictor, and Koestler 1991; May et al. 1993; Tayler 1992).

The biochemical deterioration of stone due to corrosive metabolites occurs when inorganic and organic acids form. These acids decompose stone minerals by producing salts and chelates, some of which may be subsequently dissolved and washed away. An increased volume of soluble salts or chelates may also cause stresses in the pores, resulting in the formation of cracks (Saxena, Jain, and Singh 1991; Jain, Saxena, and Singh 1991; Jain, Mishra, and Singh 1993). Insoluble salts and chelates may concentrate or precipitate on the stone surface as crusts.

Carbon dioxide, produced by aerobic organisms through respiration, changes into carbonic acid in an aqueous environment. Carbonic acid can dissolve carbonates such as limestones and marbles (Caneva, Nugari, and Salvadori 1991).

The aesthetic or visual effects of biodeterioration of stone are conceptually subjective but nonetheless important. The growth of biological populations on stone surfaces alters their appearance due to chromatic alterations and development of biological patinas. Several decades ago, climbing plants were considered to enhance the aesthetic value of ruins (Martines 1983), as were algal and lichen patinas. Today, it is usually considered preferable to eliminate biological growth for conservation reasons and to create an impression of order and care.

Microorganisms found growing on otherwise undamaged stone surfaces, utilizing surface dirt and detritus, may not initially cause any noticeable change in the chemical composition of the stone (Realini, Sorlini, and Bassi 1985; Pietrini et al. 1985). However, with time, this fouling may exceed purely aesthetic biodeterioration and cause physicochemical damage to the stone.

Bacteria and Bacterial Biodeterioration

Bacteria

Bacteria are a group of prokaryotic unicellular or colonial organisms of various shapes (spherical, rodlike, or spiral). They may be motile or immotile. They include autotrophic and heterotrophic species (Martin 1985; Walker 1989; Caneva, Nugari, and Salvadori 1991). Owing to their simple ecological and nutritional needs, they develop easily on outdoor stone objects and monuments, especially where the surface exhibits a high water content. Bacteria are small, and their presence on stone is normally determined microscopically or by the chemical changes that they bring about in the stone. Table 2.1 lists various species of bacteria that have been found in historic buildings and monuments in tropical regions.

Nitrogen and sulfur bacteria are the only chemoautotrophic bacteria that have been detected on stone monuments in tropical regions.

Table 2.1 Bacteria reported found in historic buildings and monuments in tropical regions

Organism	Surface	Occurrence	Reference
Chemoautotrophs			
Sulfur-oxidizing bacteria			
Thiobacillus sp.	Sandstone, andesite	Cambodia, Indonesia	Voute 1969
Nitrifying bacteria			
Nitrosomonas sp.	Quartzite, soapstone	Thailand, Brazil	Aranyanak 1992; Warscheid et al. 1992
Nitrosococcus sp.	n.s.	Thailand	Aranyanak 1992
Nitrobacter sp.	Quartzite, soapstone	Brazil	Warscheid et al. 1992
Chemoheterotrophs			
Bacillus sp.	Limestone	Thailand, Cuba	Aranyanak 1992; Cepero et al. 1992; Martinez, Castro, and Sanchez 1993
Desulfovibrio sp.	Sandstone	Cambodia, Indonesia	Voute 1969
Pseudomonas sp.	n.s.	Thailand	Aranyanak 1992
Micrococcus sp.	Limestone	Thailand, Cuba	Aranyanak 1992; Cepero et al. 1992; Martinez, Castro, and Sanchez 1993
Staphylococcus sp.	Limestone	Cuba	Cepero et al. 1992
Actinomycetes			
Nocardia sp.	n.s.	Thailand	Aranyanak 1992
Micropolyspora sp.	n.s.	Thailand	Aranyanak 1992
Micromonospora sp.	n.s.	Thailand	Aranyanak 1992
Microellobosporium sp.	n.s.	Thailand	Aranyanak 1992
Streptomyces sp.	Sandstone	Cambodia	Hyvert 1966
Photoautotrophs			
Cyanobacteria			
Anabaena anomala	Andesite	Indonesia	Hyvert 1972
Anacystis montana	n.s.	Singapore	Wee and Lee 1980
Anacystis thermale	n.s.	Singapore	Wee and Lee 1980

Organism	Surface	Occurrence	Reference
Aphanothece pallida	Andesite	Indonesia	Hyvert 1972
Aphanothece castagnei	Andesite	Indonesia	Hyvert 1972
Aulosira fertilissima	Andesite	Indonesia	Hyvert 1972
Calothrix parietina	n.s.	Singapore	Wee and Lee 1980
Chlorogloea sp.	Sandstone	Cambodia	Fusey and Hyvert 1964
Chroococcus turgidus	Marble, sandstone	India	Tecneco 1976
Chroococcus sp.	n.s.	India	Garg et al. 1995
Entophysalis sp.	Andesite	Indonesia	Hyvert 1972
Gloeocapsa magma	Andesite	Indonesia	Hyvert 1972
Gloeocapsa punctata	Andesite	Indonesia	Hyvert 1972
Gloeocapsa sp.	Sandstone	Cambodia	Fusey 1964
Gloeocapsa livida	Marble, sandstone	India	Tecneco 1976
Gomphosphaeria aponina	Marble, sandstone	India	Tecneco 1976
Heterohormogonium sp.	Andesite	Indonesia	Hyvert 1972
Lyngsya cinerescens	Marble, sandstone	India	Tecneco 1976
Lyngsya lutea	Marble, sandstone	India	Tecneco 1976
Lyngsya maiuscola	Marble, sandstone	India	Tecneco 1976
Lyngsya sordida	Marble, sandstone	India	Tecneco 1976
Microcystis ramosa	Marble, sandstone	India	Tecneco 1976
Nostoc calcicola	Andesite	Indonesia	Hyvert 1972
Nostoc ellipsosporum	Andesite	Indonesia	Hyvert 1972
Nostoc microscopicum	Andesite	Indonesia	Hyvert 1972
Nostoc minutissima	Andesite	Indonesia	Hyvert 1972
Nostoc sp.	n.s.	India	Garg et al. 1995
Oscillatoria annae	Marble, sandstone	India	Tecneco 1976
Oscillatoria sp.	Limestone	Guatemala, Honduras, Singapore	Hale 1980; Wee and Lee 1980
Phormidium angustissimus	Marble, sandstone	India	Tecneco 1976
Phormidium sp.	Limestone	Guatemala, India	Hale 1980; Garg et al. 1995
Porphyrosiphon sp.	Sandstone	Cambodia	Fusey and Hyvert 1964
Schizothrix calcicola	n.s.	Singapore	Wee and Lee 1980
Schizothrix friesii	n.s.	Singapore	Wee and Lee 1980
Schizothrix rubella	n.s.	Singapore	Wee and Lee 1980
Scytonema julianum	Andesite	Indonesia	Hyvert 1972
Scytonema mirabile	Andesite	Indonesia	Hyvert 1972
Scytonema sp.	Andesite, limestone, sandstone	Indonesia, Cambodia, Singapore	Hyvert 1972; Fusey and Hyvert 1964
Stigonema hormoides	Andesite	Indonesia	Hyvert 1972
Stigonema minutum	Andesite	Indonesia	Hyvert 1972
Synechocystis aquatilis	Andesite, marble, sandstone	Indonesia, India	Hyvert 1972; Tecneco 1976
Tolypothrix campylonemoides	Andesite	Indonesia	Hyvert 1972
Tolypothrix conglutinale	Andesite	Indonesia	Hyvert 1972
Tolypothrix sp.	Sandstone	Cambodia	Fusey and Hyvert 1964

n.s. = not specified

Other chemoautotrophic bacteria, such as iron and calcite bacteria, may be present but have thus far not been isolated.

Actinomycetes are a group of mostly aerobic, heterotrophic, immotile bacteria that were at one time considered microscopic fungi because they exhibit forms with ramified mycelia during all or some phases of their life cycle (Martin 1985; Walker 1989; Caneva, Nugari, and Salvadori 1991). They occur in great numbers with fungi, algae, and nitrogen-fixing bacteria in environments characterized by warmth (10–30 °C), constant high humidity (90–100%), and the presence of plentiful organic matter (Delvert 1963; Hyvert 1966; Voute 1969; Caneva, Nugari, and Salvadori 1991).

Cyanobacteria, commonly known as blue-green algae, are mostly colonial, immotile photoautotrophic organisms containing

chlorophyll and other types of pigments (carotenoids, xanthophylls, phycocyanins, phycoerythrins). Each cell is surrounded by a gelatinous pigmented sheath that imparts various colors to the cells (golden yellow, brown, red, emerald green, dark blue, violet, azure) (Martin 1985; Walker 1989; Caneva, Nugari, and Salvadori 1991). The sheath allows rapid absorption and slow release of moisture, allowing the cyanobacteria to survive in adverse environmental conditions such as persistent desiccation. Some species are able to fix nitrogen.

Bacterial biodeterioration

In tropical environments, three bacterial groups have been identified as potentially causing the deterioration of stone structures: chemoautotrophic sulfur-oxidizing and nitrifying bacteria; photoautotrophic cyanobacteria; and heterotrophic bacteria, including actinomycetes. These bacteria are particularly active on limestones and calcareous sandstones (Stambolov and Van Asperen De Boer 1967, 1969; Winkler 1975; Monte Sila and Tarantino 1981; Strzelczyk 1981; Ciarallo et al. 1985; Gugliandolo and Maugeri [1988]; Lewis et al. 1987; Lewis, May, and Bravery 1988; Jain, Mishra, and Singh 1993; Mishra et al. 1995).

Autotrophic sulfur-oxidizing bacteria attack stone under aerobic conditions by producing inorganic acids (Voute 1969; Jain, Mishra, and Singh 1993; May et al. 1993). They oxidize sulfur-containing nutrients from the soil to sulfuric acid. This sulfuric acid can react with constituents of the stone to form sulfates, which appear as crusts on the stone surfaces. These sulfates may be dissolved by rainwater (e.g., gypsum) or may be precipitated within the pores of the stone, where, upon recrystallization, they can exert tremendous stresses on the pore walls due to an increase in volume causing stone damage, manifested as exfoliation. Calcareous stones are especially affected (Lepidi and Schippa 1973; Jain, Mishra, and Singh 1993).

It has been suggested that sulfur-reducing bacteria in the soil at the base of stone monuments can reduce sulfates to sulfides. These sulfides then pass into stone through capillary action and provide an energy source to sulfur-oxidizing bacteria (Pochon and Jaton 1967; Tiano et al. 1975; May et al. 1993). Sulfur compounds from pollutants or from previous biological colonization may also act as an energy source for sulfur-oxidizing bacteria (Caneva, Nugari, and Salvadori 1991; May et al. 1993).

Autotrophic nitrifying bacteria oxidize ammonia to nitrite and nitrate ions, which may result in nitric acid formation. Stone dissolution, powdering, and formation of soluble nitrate salts that appear as efflorescence on the stone surface are processes that have all been demonstrated experimentally (Jain, Saxena, and Singh 1991).

Other autotrophic bacteria are capable of oxidizing some iron and manganese minerals. They contribute to dissolution of cations from the stone and surface staining (Koestler and Santoro 1988; Wolters et al. [1988]). Although such bacteria have not yet been isolated from stone monuments in tropical regions, they may still be significant (Jain, Mishra, and Singh 1993).

Heterotrophic bacteria have received comparatively little attention, although their presence on stone in tropical regions has been well established (Hueck–van der Plas 1968; Voute 1969; Hyvert 1972; Wee and Lee 1980; Cepero et al. 1992; Aranyanak 1992; Warscheid et al. 1992; Martinez, Castro, and Sanchez 1993). Their deterioration mechanism involves the evolution of biogenic acids (some of which have chelating abilities) that may cause stone dissolution through mobilization of cations such as Ca^{+2}, Fe^{+3}, Mn^{+2}, Al^{+3}, and Si^{+4} (Duff, Webley, and Scott 1963; Webley, Henderson, and Taylor 1963; Caneva and Salvadori 1988; Jain, Saxena, and Singh 1991). Some heterotrophic bacteria have also been associated with the discoloration of stone surfaces (Realini, Sorlini, and Bassi 1985; Tayler 1992).

Aggressive action of cyanobacteria on the stone surface where they develop has been considered negligible by some authors (Dukes 1972; Tiano 1987), although this view is still controversial. It is well known that cyanobacteria cause aesthetic damage to stone monuments by creating variously colored microbial films on their surfaces, thereby soiling the structures and giving them an unsightly appearance of neglect. These microbial films may contain significant amounts of adsorbed inorganic materials derived from the substrata (quartz, calcium carbonate, clay) and detritus (dead cells or microbial by-products). The slimy surfaces of these bacteria facilitate adherence of airborne particles of dust, pollen, oil, and coal ash, giving rise to hard crusts and patinas that are difficult to eliminate (Hueck–van der Plas 1965; Fogg et al. 1973; Saiz-Jimenez 1984; Wilderer and Characklis 1989).

Apart from the aesthetic deterioration mentioned in most of the literature on cyanobacteria on historic buildings, some references describe direct physical and chemical damage produced by them (Hyvert 1973; Danin 1983; Saiz-Jimenez 1994). It has been reported that the presence of a microbial layer of epilithic cyanobacteria may help create a distinctive microenvironment where respiration and photosynthesis may produce acids as by-products. These acids cause biochemical deterioration of the stone through the etching of mineral components and dissolution of binding minerals, especially in carbonates (Viles 1987; Tiano 1993).

It has been documented that pitting of marble by cyanobacteria has been due to their establishment in microscopic depressions such as crystal interfaces of the stone. They increase the local water retention capacity of the stone by dissolving the adjacent material, which promotes further increase in their population. Crystal coherence decreases in areas dominated by cyanobacteria, and rainwater detaches the crystals, leading to pitting (Golubic, Friedmann, and Scheider 1981; Danin 1986; Danin and Caneva 1990; Caneva et al. 1994).

Biophysical deterioration of the stone may also occur. Considerable force may be exerted through repeated shrinking and relaxing of the slimy sheath of the cyanobacteria during their cycle of drying and moistening. This eventually loosens mineral grains of the stone surface (Friedmann 1971; Golubic 1973; Campbell 1979; Anagnostidis, Economou-Amilli, and Roussomoustakaki 1983; Robins et al. 1986; Shephard 1987; De Winder et al. 1989).

Cyanobacteria may also play a direct role in supporting the growth of heterotrophic organisms such as fungi or other bacteria that have a higher destructive potential by becoming their nutrient sources (Strzelczyk 1981; Saiz-Jimenez 1984; Koestler et al. 1985; Kuroczkin et al. [1988]; Andreoli et al. [1988]; May and Lewis [1988]; Tripathi and Talpasayi 1990).

Actinomycetes often occur with fungi, algae, and nitrifying bacteria (Delvert 1963; Hyvert 1966; Voute 1969). It has not been well established whether or not their metabolic activity contributes to the biodeterioration of stone in the tropics. Laboratory experiments have indicated that their acidic metabolic products (e.g., oxalic acid and citric acid) can attack calcareous stone, hydrolyze some silicate minerals, or chelate the metallic ions, leaving a more easily soluble lattice.

Fungi and Fungal Biodeterioration

Fungi

Fungi are a group of chemoheterotrophic organisms characterized by unicellular or multicellular filamentous hyphae. They lack chlorophyll and, thus, the ability to manufacture their own food by using the energy of sunlight (Martin 1985; Walker 1989; Caneva, Nugari, and Salvadori 1991). Hence, they cannot live on stone, even if it is permanently wet, unless some organic food is present. The waste products of algae and bacteria (or the dead cells of these organisms), decaying leaves, and bird droppings can provide such food sources (Sharma et al. 1985). Table 2.2 lists fungi found on stone monuments in tropical regions.

Fungal biodeterioration

Several species of fungi have been isolated from weathered stones, especially in tropical areas. Stone, being inorganic, does not by itself favor the growth of fungi. The presence of organic residues on stone, however, encourages their growth. Research in areas other than the tropics suggests that, once established, fungi degrade stone chemically (Silverman and Munoz 1970; Eckhardt 1985; Griffin, Indictor, and Koestler 1991) and sometimes mechanically (Bassi, Barbieri, and Bonecchi 1984).

Biophysical deterioration of stone has been demonstrated by the extensive penetration by fungal hyphae into decayed limestone and, apparently, by burrowing into otherwise sound stone (Lepidi and Schippa 1973). Hyphal penetration along crystal planes in calcitic and dolomitic stones has also been demonstrated (Koestler et al. 1985). Some endolithic fungi are reported to produce pitting through a chemical action (Danin 1986).

The biochemical action of fungi on stone appears to be a more important process than mechanical degradation. Fungi are believed to be potential contributors to decay of limestones, silicate minerals (mica and orthoclase), and iron- and magnesium-bearing minerals (biotite, olivine, pyroxene), but the extent of total decay attributable solely to them is undetermined.

Table 2.2 Fungi found on stone monuments in tropical regions

Organism	Surface	Occurrence	Reference
Alternaria sp.	Marble, sandstone	India	Tecneco 1976
Aspergillus elegans	Andesite	Indonesia	Hyvert 1972
Aspergillus flavus	Andesite, limestone, marble, sandstone	Cuba, Indonesia, India	Cepero et al. 1992; Hyvert 1972; Tecneco 1976
Aspergillus nidulans	Marble, sandstone	India	Tecneco 1976
Aspergillus niger	Limestone, marble, sandstone	Indonesia, Cuba, India	Hyvert 1972; Cepero et al. 1992; Tecneco 1976
Aspergillus versicolor	Marble, limestone	Cuba	Cepero et al. 1992
Aureobasidium sp.	Marble, limestone	Cuba	Cepero et al. 1992
Blastomyces dermatitis	n.s.	India	Mathur 1983–84
Candida albicans	Basalt	India	Mathur 1983–84
Cephalosporium sp.	Limestone	Cuba	Cepero et al. 1992
Cladosporium cladosporoides	Andesite	Indonesia	Hyvert 1972
Cladosporium sp.	Soapstone, quartzite, sandstone	Brazil, Cuba, Cambodia	Warscheid et al. 1992; Cepero et al. 1992; Fusey and Hyvert 1966
Cladosporium sphaerospermum	Andesite	Indonesia	Hyvert 1972
Cunninghamella echinulata	Andesite	Indonesia	Hyvert 1972
Curvularia lunata	Andesite, marble, sandstone	Indonesia, India	Hyvert 1972; Tecneco 1976
Curvularia verrugulosa	Marble, sandstone	India	Tecneco 1976
Curvularia sp.	Sandstone	Cambodia	Fusey and Hyvert 1966
Fusarium roseum	Andesite, limestone, marble	Cuba, Indonesia	Hyvert 1972; Cepero et al. 1992
Fusarium sp.	Marble, sandstone	India	Tecneco 1976
Gliocladium virens	Andesite	Indonesia	Hyvert 1972
Humicola grisea	Marble, sandstone	India	Tecneco 1976
Lipomyces neoformans	Stone, sandstone	India	Mathur 1983-84
Macrophoma sp.	Marble, sandstone	India	Tecneco 1976
Monilia sp.	Limestone	Cuba	Cepero et al. 1992
Penicillium multicolor	Andesite	Indonesia	Hyvert 1972
Penicillium crustosum	Soapstone, quartzite	Brazil	Warscheid et al. 1992
Penicillium frequentans	Marble, limestone	Cuba	Cepero et al. 1992
Penicillium glabrum	Soapstone, quartzite	Brazil	Warscheid et al. 1992
Penicillium lilacinum	Andesite	Indonesia	Hyvert 1972
Penicillium notatum	Marble, sandstone	India	Tecneco 1976
Rhizopus arrhizus	Andesite	Indonesia	Hyvert 1972

n.s. = not specified

The deterioration of marble, limestone, granite, and basalt by filamentous fungi through the action of excreted oxalic and citric acids has been reported in the literature (May et al. 1993). The acids produced by various species of fungi function as chelating agents that can leach metallic cations, such as calcium, iron, or magnesium, from the stone surface (Caneva and Salvadori 1988). Oxalic acid can cause extensive corrosion of primary minerals and the complete dissolution of ferruginous minerals through the formation of iron oxalates and silica gels.

Laboratory experiments have demonstrated that basic rocks are more susceptible to fungal attack than acidic rocks. It has also been shown in the laboratory that fungal species such as *Aspergillus niger* were able to solubilize powdered stone and chelate various minerals in a rich glucose medium because they produce organic acids such as gluconic, citric, and oxalic acids (Eckhardt 1985). Similar experiments involving stone have demonstrated the formation of oxalate crystals, which adhered to lichen and fungal hyphae or were deposited nearby (Gaustein, Cromack, and Sollins 1977; Wilson, Jones, and McHardy 1981).

The dissolution, recrystallization, and redeposition of calcite by fungi have been studied (Jones 1987; Jones and Pemberton 1987; de la Torre, Gomez-Alarcon, and Palacios 1993; de la Torre et al. 1993). Fungi have also been shown to oxidize manganese in the laboratory, causing staining in stone (Petersen, Grote, and Krumbein [1988]; Petersen et al. 1988). There have also been reports about similar effects of fungi on stone monuments (Hyvert 1966; Ionita 1971). Fungi have also been associated with the formation of a powdering stone surface (Realini, Sorlini, and Bassi 1985).

Algae and Algal Biodeterioration

Algae

Algae are diverse groups of eukaryotic, unicellular or multicellular, photoautotrophic organisms of various shapes (filamentous, ribbonlike, or platelike) that contain pigments such as chlorophyll, carotenoids, and xanthophylls. Some algae are also able to survive heterotrophically when necessary (Martin 1985; Walker 1989; Caneva, Nugari, and Salvadori 1991). Of the eleven classified groups of algae (Bold and Wynne 1985), the species of two major groups—the chlorophytes and bacillariophytes, or diatoms—have been isolated from stone monuments in tropical regions (Table 2.3).

The most important conditions for establishing algae on stone surfaces are dampness, warmth, light, and inorganic nutrients, particularly calcium and magnesium (Richardson 1973a; Riederer 1981; Siswowiyanto 1981; Singh, Jain, and Agrawal [1988]; Jain, Mishra, and Singh 1993). Many algae show a marked sensitivity to the pH of the surface, preferring acidic surfaces, but for some this value is not growth limiting (Strzelczyk 1981).

Based on their relationship with the substrate, algae can be divided into two groups: epilithic algae, which grow on the exposed surface of the substrate; and endolithic algae, which colonize the interior of the substrate. Endolithic algae may be further classified as chasmoendolithic algae, which live inside preformed fissures and cavities open to the surface of the substrate; cryptoendolithic algae, which colonize structural cavities within porous substrate; and euendolithic algae, which actively penetrate into substrate (Caneva, Nugari, and Salvadori 1991).

Algal biodeterioration

Several authors have reported examples of disfigurement and possible damage to stone monuments in tropical regions due to presence of algae (Fusey and Hyvert 1966; Hyvert 1972; Wee and Lee 1980; Lee and Wee 1982). However, evidence for algal contribution to the decay process of stone has been conflicting. Damage to building stone caused by algae associated with bacteria and fungi has been reported, but decay has so far not been ascribed to algae alone (Krumbein and Lange 1978).

Loss of aesthetic value is considered to be the most obvious type of damage caused by algae to stone monuments. Algal communities

Table 2.3 Algae isolated from stone monuments in tropical regions

Organism	Surface	Occurrence	Reference
Chlorophytes			
Chlorella sp.	n.s.	Singapore	Wee and Lee 1980
Chlorococcum humicola	Andesite	Indonesia	Hyvert 1972
Chlorococcum sp.	n.s.	Singapore, India	Wee and Lee 1980; Garg et al. 1995
Cylindrocapsa sp.	n.s.	Singapore	Wee and Lee 1980
Dermococcus sp.	Limestone	Guatemala	Hale 1980
Gonggrosira sp.	Andesite	Indonesia	Hyvert 1972
Hormidium sp.	n.s.	Singapore	Wee and Lee 1980
Oocystis sp.	Andesite	Indonesia	Hyvert 1972
Pleurococcus sp.	Sandstone, marble, limestone	Cambodia	Fusey and Hyvert 1964
Trentopohlia sp.	Limestone, andesite	Guatemala, Honduras, Singapore, Indonesia	Hale 1980; Wee 1988; Hyvert 1972
Bacillariophytes			
Achnautes lanceolata	Andesite	Indonesia	Hyvert 1972
Caloneis bacillum	Andesite	Indonesia	Hyvert 1972
Cymbella ventricosa	Andesite	Indonesia	Hyvert 1972
Navicula breakkaensis	Andesite	Indonesia	Hyvert 1972
Navicula minima	Andesite	Indonesia	Hyvert 1972
Navicula mutica	Andesite	Indonesia	Hyvert 1972
Navicula sp.	Limestone	Singapore	Wee and Lee 1980
Nitzschia amphybia	Andesite	Indonesia	Hyvert 1972
Nitzschia denticula	Andesite	Indonesia	Hyvert 1972
Nitzschia frustulum	Andesite	Indonesia	Hyvert 1972
Pinnularia borealis	Andesite	Indonesia	Hyvert 1972
Pinnularia hemiptera	Andesite	Indonesia	Hyvert 1972
Pinnularia intermedia	Andesite	Indonesia	Hyvert 1972
Pinnularia interrupta	Andesite	Indonesia	Hyvert 1972
Pinnularia leptosoma	Andesite	Indonesia	Hyvert 1972
Pinnularia mesolepta	Andesite	Indonesia	Hyvert 1972

n.s. = not specified

are usually readily recognizable on stone surfaces because they form patina or sheets varying in extent, thickness, consistency, and color. In well-lit and relatively dry environments, patinas on stone surfaces are thin, tough, sometimes green, and very often gray or black. However, in poorly lit and damp places (interiors of monuments, walls of caves), they are thick, gelatinous, and of various colors such as green, yellow, orange, violet, and red. They cause deterioration primarily by staining the stone surfaces and obscuring relevant details. Staining generally results from the different-colored pigments of the algae (Caneva, Nugari, and Salvadori 1991; Tiano 1993; Saiz-Jimenez 1994).

Although direct damage by algae may not always be significant, they indirectly damage stone by supporting growth of more corrosive biodeteriogens (lichens, mosses, liverworts, and higher plants). This is a natural successional sequence, but unless there is a complete lack of maintenance, the final stage does not develop (Wee and Lee 1980; Garg, Dhawan, and Agrawal 1988).

Algae may also cause biochemical deterioration. They produce a variety of metabolites, predominantly organic acids (Round 1966; Hueck–van der Plas 1968; Griffin, Indictor, and Koestler 1991; Jain, Mishra, and Singh 1993). These acids either actively dissolve stone constituents or increase their solubility in water and stimulate migration

of salts in stone, causing powdering of its surface. The change in solubility of stone constituents alters properties of the stone, such as its coefficient of thermal expansion, which can increase the sensitivity of stone to physical processes of deterioration. Algae also secrete other products of metabolism, such as proteins, which are chelating agents contributing to the dissolution of stone (Jain, Mishra, and Singh 1993), and sugars, which promote the growth of heterotrophic epilithic bacteria (Bell, Lang, and Mitchell 1974). Algal growth, together with the dissolutive effect of water, may also result in microcavities, or pitting of the stone.

It is also possible that endolithic algae may widen preexisting fissures in stone through increased volume and mass resulting from their growth and water-binding capacity. However, in all such reported cases of actual biophysical deterioration of the stone surface, the algae were growing together with fungi. Thus far, it has not been established that the deterioration was solely due to the algae and not to fungal activity (Garg, Dhawan, and Agrawal 1988).

Lichens and Lichenic Biodeterioration

Lichens

Lichens are a large group of composite organisms formed by the symbiotic association of chlorophyta or cyanobacteria and a fungus. Due to their resistance to desiccation and extreme temperature and efficiency in accumulating nutrients, lichens occur in a wide range of habitats, including those normally hostile to other life forms (Martin 1985; Walker 1989; Caneva, Nugari, and Salvadori 1991). Together with cyanobacteria they play an important role as pioneer organisms in colonizing rocks. Three types of lichens that attach themselves to the surface with devices such as rhizoids (foliose and fruticose lichens) and hyphae (crustose lichens) have been isolated in tropical regions (Seshadri and Subramanian 1949; Hale 1980). They can be epilithic (living over stone) or endolithic (entirely living beneath a stone surface). (See Table 2.4.)

Lichenic biodeterioration

The characteristics of lichens and their deleterious effects on stone have been reviewed by several authors (Hale 1983; Bech-Anderson and Christensen 1983; Florian 1978; Jones and Wilson 1985; Giacobini et al.

Table 2.4 Lichens found on stone monuments in tropical regions

Organism	Surface	Occurrence	Reference
Crustose			
Aspicilia cinerea	Limestone	Honduras	Hale 1980
Arthopyrenia sp.	Limestone	India	Singh and Upreti 1991
Bacidia rosella	Andesite	Indonesia	Hyvert 1972
Bacidia sp.	Limestone	Guatemala, India	Hale 1980; Singh and Upreti 1991
Biatoria immersa	Andesite	Indonesia	Hyvert 1972
Blastenia sp.	Limestone	Guatemala, Honduras	Hale 1980

Organism	Surface	Occurrence	Reference
Caloplaca sp.	Sedimentary rock, limestone	India, Honduras	Singh and Sinha 1993; Hale 1980
Candelariella sp.	Limestone	Honduras	Hale 1980
Chiodecton antillarum	Limestone	Guatemala, Honduras	Hale 1980
Chiodectron sp.	Limestone	Guatemala	Hale 1980
Diploschistes sp.	Sandstone	India	Singh and Sinha 1993
Endocarpon fusitum	Andesite	Indonesia	Hyvert 1972
Endocarpon nanum	Limestone	India	Singh and Upreti 1991
Endocarpon pusillum	Lime plaster	India	Singh and Upreti 1991
Endocarpon nigro-zonatum	Lime plaster	India	Singh and Upreti 1991
Endocarpon rosettum	Lime plaster	India	Singh and Upreti 1991
Endocarpon sp.	n.s.	India	Garg et al. 1995
Ephebe pubescens	Andesite	Indonesia	Hyvert 1972
Lecanora sp.	Limestone	Honduras, India	Hale 1980; Garg et al. 1995
Leptotrema santense	Limestone	Guatemala, Honduras	Hale 1980
Peltigera malacea	Andesite	Indonesia	Hyvert 1972
Phyllopsora corallina	Limestone	Guatemala, Honduras	Hale 1980
Placynthium nigrum	Andesite	Indonesia	Hyvert 1972
Porina fafinea	Andesite	Indonesia	Hyvert 1972
Septrotrema pseudoferenula	Andesite	Indonesia	Hyvert 1972
Thermucis velutina	Andesite	Indonesia	Hyvert 1972
Verrucaria rupestris	Andesite	Indonesia	Hyvert 1972

Foliose

Candelaria concolor	Limestone	Honduras	Hale 1980
Candellaria sp.	Sandstone	India	Singh and Sinha 1993
Coccocarpia cronia	Limestone	Guatemala, Honduras	Hale 1980
Collema sp.	Limestone	Guatemala, Honduras	Hale 1980
Dirinaria confluens	Limestone	Honduras	Hale 1980
Dirinaria picta	Limestone	Guatemala, Honduras	Hale 1980
Dirinaria sp.	Sandstone	India	Singh and Sinha 1993
Heterodermia casarettiana	Limestone	Honduras	Hale 1980
Heterodermia leucomelaena	Limestone	Honduras	Hale 1980
Heterodermia sp.	Sandstone, limestone	India, Honduras	Singh and Sinha 1993; Hale 1980
Laboria pulmonia	Andesite	Indonesia	Hyvert 1972
Leptogium sp.	Limestone	Guatemala, Honduras	Hale 1980
Parmelia sp.	Sandstone	India	Singh and Sinha 1993
Parmelia tinctorum	Andesite	Indonesia	Hyvert 1972
Parmelia grayana	Granite	India	Gayathri 1982
Parmeliella pannosa	Limestone	Guatemala, Honduras	Hale 1980
Parmelina minarum	Limestone	Honduras	Hale 1980
Parmotrema crinitum	Limestone	Honduras	Hale 1980
Parmotrema cristiferum	Limestone	Honduras	Hale 1980
Parmotrema dilatatum	Limestone	Honduras	Hale 1980
Parmotrema endosulphureum	Limestone	Guatemala, Honduras	Hale 1980
Parmotrema mordenii	Limestone	Honduras	Hale 1980
Parmotrema praesoediosum	Limestone	Guatemala, Honduras	Hale 1980
Parmotrema sancti-angelii	Limestone	Honduras	Hale 1980
Parmotrema sulphuratum	Limestone	Guatemala, Honduras	Hale 1980
Parmotrema tinctorum	Limestone	Honduras	Hale 1980
Peltula sp.	Sandstone	India	Singh and Sinha 1993
Peltula obscurans	Lime plaster	India	Singh and Upreti 1991
Peltula patellata	Lime plaster	India	Singh and Upreti 1991
Phylliscum indicum	Lime plaster	India	Singh and Upreti 1991
Phylliscum macrosporum	Lime plaster	India	Singh and Upreti 1991
Physcia sorediosa	Limestone	Guatemala, Honduras	Hale 1980
Pyxine sp.	Sandstone	India	Singh and Sinha 1993
Sticta weigelii	Limestone	Honduras	Hale 1980
Usnea rubicunda	Limestone	Honduras	Hale 1980
Xanthoparmelia subramigera	Limestone	Honduras	Hale 1980

Fruticose

Roccella fuciformis	Andesite	Indonesia	Hyvert 1972
Roccella montagnie	Granite	India	Gayathri 1982

n.s. = not specified

1985; Lallemant and Deruelle [1978]; Garg, Dhawan, and Agrawal 1988; Seaward 1988; Seaward et al. 1989; Monte 1991; Singh and Sinha 1993).

Biophysical stone degradation by lichens results primarily from the penetration of the attachment devices of the thallus into the pores, preexisting cracks, and fissures in the stone. These cracks and fissures may subsequently widen due to an increase in the mass of the thallus during growth. Periodic detachment of the thallus related to fluctuations in humidity may also result in the loss of adherent mineral fragments (Hueck–van der Plas 1968; Riederer 1981, 1984; Singh and Upreti 1991). Loosening of minerals in the form of granules may occur due to chemical weathering, but their detachment from the surface is by the physical activity of lichens (Syers and Iskandar 1973; Jones and Wilson 1985). Porous, calcareous sedimentary rocks have been found particularly susceptible to physical penetration by lichens. Due to the nature of their attachment, foliose and crustose lichens are probably the most harmful biodeteriogens (Riederer 1981, 1984; Singh and Upreti 1991).

Carbonic acid is a potent weathering agent, especially over long periods of time (Jones and Wilson 1985). The carbon dioxide produced by lichens due to respiration is transformed within their thallus into carbonic acid. Owing to their slow metabolic activity, however, the contribution of this carbonic acid to the disintegration of the stone surface is significant only after a considerable period of time.

Several studies pertaining to the ability of lichens (particularly crustose) to cause chemical disintegration of the surface minerals indicate that the biogenic organic acids and other chelating agents produced by the organism play significant roles (Iskandar and Syers 1972; Siswowiyanto 1981; Jones, Wilson, and McHardy 1987; Pallecchi and Pinna [1988]).

The organic acids produced by lichens are capable of attacking calcium, magnesium, and iron minerals, as well as silicate minerals such as mica and orthoclase. This action causes a stone surface to appear honeycombed with etch pits. Sometimes intergranular cementing substances are acted upon, resulting in the loosening of rock mineral grains (Jones, Wilson, and McHardy 1981; Wilson and Jones 1983; Jones and Wilson 1985). Biopitting due to lichens has been observed mostly in marble monuments in Europe (Krumbein 1987; Krumbein, Petersen, and Schellnhuber 1989; Danin and Caneva 1990; Del Monte 1991; Saiz-Jimenez 1994). This may also be the case for monuments in tropical regions, although such studies have not been specifically conducted there. Some authors attribute pitting to the action of endolithic lichens (Krumbein, Petersen, and Schellnhuber 1989; Del Monte 1991); however, others consider that pit formation results from the action of water on the stone surfaces with structural and textural defects (Saiz-Jimenez 1994).

Effects of lichens on stone vary according to the stone's chemical composition and crystallographic structure (Jones, Wilson, and McHardy 1987). Generally, carbonate and ferromagnesian silicate minerals weather easily (Jones, Wilson, and McHardy 1981) and show characteristic dissolution features. Olivine grains exhibit deeply penetrating etch pits, whereas the surfaces of augite grains may reveal deep, cross-cutting, trenchlike features (Jones, Wilson, and McHardy 1981).

Feldspars are usually more resistant to lichen activity, although calcium-rich feldspars may be easily reduced, and certain plagioclase feldspars may be characterized by extensive etching out of lamellar intergrowths. Quartz does not seem to have been much affected by lichens, but it is not completely invulnerable. There are reports of etching of quartzite surfaces by a particular species of lichen (Hallbaur and Jahns 1977; Jones, Wilson, and McHardy 1981).

Weathering of granite statues due to lichen growth has been reported in India (Gayathri 1982). The selective enrichment of lithium, sodium, potassium, zinc, lead, and cadmium was found in their thalli. An unusually high percentage (20–30%) of lecanoric acid, a chelator of metallic ions, was found in the thallus of lichens growing on monuments in Borobudur (Seshadri and Subramanian 1949). In tropical regions some importance may also be accorded to the production of chelating agents, such as polyphenolic compounds, by lichens (Jones and Wilson 1985). Their role in stone deterioration is established but less well studied than the role of oxalic acid.

The fungal half of the lichen produces oxalic acid in addition to other organic acids. The accumulation of acids increases with the age of the lichen and is more prevalent in calcium-loving species. Calcium carbonate of the stone is slightly soluble in water and is attacked by oxalic acid. As a result many lichens penetrate into the stone material and become endolithic (Syers and Iskandar 1973). Action of oxalic acids with the metallic ions in minerals produces insoluble oxalate crusts (Singh and Sinha 1993). Crystals of calcium oxalate monohydrate, calcium oxalate dihydrate, magnesium oxalate dihydrate, and manganese oxalate dihydrate have been identified at the stone-lichen interface (Ascaso, Galvan, and Ortega-Calvo 1976; Salvadori and Zitelli 1981; Ascaso, Galvan, and Rodriguez-Pascual 1982; Purvis 1984; Jones, Wilson, and McHardy 1987).

There are many examples of stone deterioration resulting from oxalate formation, an action that is attributed to crustose lichens (Siswowiyanto 1981). Oxalate formation may result in discoloration by a surface patina, which is most pronounced on light-colored stones. Other instances of pigmented calcium oxalate films have been attributed to past decorative or preservative treatments (Charola et al. 1986; Agrawal et al. 1987; Lazzarini and Salvadori 1989).

Biodeterioration by Mosses and Liverworts

Mosses and liverworts

Mosses and liverworts are bryophytes, a transitional group of the kingdom Plantae. They represent a bridge between primitive plants without tissues or organs and evolved plants with differentiated tissues and organs. They are simple photoautotrophic organisms that contain pigments (chlorophyll and carotenoids) and possess rudimentary rootlike organs (rhizoids) but no vascular tissues or transport organs (phloem and xylem). They frequently occur in association with algae in a variety of

damp habitats from fresh water to damp rock surfaces in tropical regions (Martin 1985; Walker 1989; Caneva, Nugari, and Salvadori 1991). Table 2.5 lists some common mosses and liverworts that have been found on stone monuments in tropical regions.

Biodeterioration caused by mosses and liverworts

Biodeterioration of stone by mosses and liverworts is predominantly aesthetic. Mosses occur only where there are humus deposits, which may result from accumulations of dead algae. As mosses die, the humus deposits extend, and these cause indirect damage to the monument by supporting the growth of more destructive higher plants (Shah and Shah 1992–93).

Mosses and liverworts may cause some degree of biochemical disintegration of stone surfaces. Due to the higher acidity of their rhizoids, these organisms have a high capacity for extracting mineral cations from the stones (Bech-Anderson 1986; Caneva and Salvadori 1988; Garcia-Rowe and Saiz-Jimenez 1991; Shah and Shah 1992–93; Saiz-Jimenez 1994). They also produce carbonic acids as a result of cellular respiration processes that are harmful to the stone over an extended period of time.

The mechanical action is less threatening than in higher plants because these organisms possess rhizoids rather than real roots. Mosses grow in high-humidity environments and are generally found at the base of porous stone walls. The presence of clay in the stone favors their growth (Hyvert 1972). Although rhizoids are capable of penetrating stone,

Table 2.5 Mosses and liverworts found on stone monuments in tropical regions

Organism	Surface	Occurrence	Reference
Aongstroemia orientalis	Andesite	Indonesia	Hyvert 1972
Barbula indica	Limestone	Guatemala	Hale 1980
Barbula javanica	Andesite	Indonesia	Hyvert 1972
Bryum coronatum	Stone, limestone	Guatemala, Indonesia	Hale 1980; Hyvert 1972
Calymperes sp.	Limestone	Guatemala, Honduras	Hale 1980
Ectropothecium monumentum	Andesite	Indonesia	Hyvert 1972
Eusomolejeunea clausa	Limestone	Guatemala	Hale 1980
Frullania riojaneirensis	Limestone	Honduras	Hale 1980
Frullania squarrosa	Limestone	Guatemala	Hale 1980
Groutiella schlumbergeri	Limestone	Guatemala	Hale 1980
Haplozia javanica	Andesite	Indonesia	Hyvert 1972
Hyalophila involuta	Limestone	Guatemala	Hale 1980
Leijeunea calcicola	Limestone	Guatemala	Hale 1980
Lejeunea flava	Limestone	Honduras	Hale 1980
Marchantia chenopoda	Limestone	Guatemala	Hale 1980
Mastigolejeunea auriculata	Limestone	Guatemala, Honduras	Hale 1980
Neckeropsis undulata	Limestone	Guatemala	Hale 1980
Neohyophila sprengelii	Limestone	Honduras	Hale 1980
Octoblepharum albidum	Limestone	Guatemala	Hale 1980
Papillaria nigrescens	Limestone	Honduras	Hale 1980
Plagiochila distinctifolia	Limestone	Guatemala	Hale 1980
Rhacomitrium tomentosum	Limestone	Honduras	Hale 1980
Sematophyllum caespitosum	Limestone	Guatemala	Hale 1980
Stereophyllum cultilliforme	Limestone	Honduras	Hale 1980
Weisia jamaicensis	Limestone	Guatemala	Hale 1980

the actual deterioration of stone because of this mechanism has not yet been established (Shah and Shah 1992–93; Jain, Mishra, and Singh 1993).

Biodeterioration by Higher Plants

Higher plants

Higher plants are photoautotrophic, pigmented (e.g., chlorophyll and carotenoids) organisms with specialized tissues and organs that permit a subdivision of activities. They have a differentiated structure composed of roots, stems, and leaves. Tissues originate from the functional differentiation of meristematic cells and can have fundamental, vascular, tegumental, and secretory functions. Higher plants can be subdivided into pteridophytes and spermatophytes on the basis of the absence or presence of seeds. Spermatophytes can be distinguished into gymnosperms and angiosperms on the basis of the absence or presence of flowers in which the reproductive organs are clustered (Martin 1985; Walker 1989; Caneva, Nugari, and Salvadori 1991). Some common higher plants that have been found on stone monuments in tropical regions are listed in Table 2.6.

Biodeterioration by higher plants

Available literature indicates that the mechanism of deterioration of stone monuments by higher plants is quite complex and consists of both physical and chemical processes. The biophysical decay is mainly due to the growth and radial thickening of the roots of plants inside the stone, which results in an increasing pressure on surrounding areas of the masonry. Compared to herbaceous plants, woody species and trees can cause much more damage due to the expansion of their root systems, which can grow to many meters in length, width, and depth (Riederer 1981; Shah and Shah 1992–93; Mishra, Jain, and Garg 1995). This is a dangerous condition that can result in collapse, detachment, and damage of stone monuments.

Root growth tends to occur in preexisting fissures or cracks on stone surfaces and in zones of least resistance—for example, in plaster or mortar between stones, thereby increasing the size of the fissures and cracks and decreasing the cohesion between stones (Gill and Bolt 1955; Winkler 1975; Mishra, Jain, and Garg 1995). It has also been established that some fast-growing species of trees can progressively lower the average moisture content of surrounding clay soil and thus cause sufficient shrinkage to damage the foundation of nearby structures. Although massive monuments may not be significantly affected in this manner, the stability of smaller buildings may be compromised (Mishra, Jain, and Garg 1995).

Biochemical deterioration results from the acidity of root tips and is responsible for the etching of minerals and the chelating action of root exudates. The acidity of root tips is maintained by a layer of H^+ ions that can be exchanged with nutritive metal cations in the solution following the lyotropic series (Williams and Coleman 1950; Keller and Frederickson 1952; Caneva and Altieri [1988]; Caneva and

Table 2.6 Higher plants found on stone monuments in tropical regions

Organism	Surface	Occurrence	Reference
Acacia arabica	n.s.	India	Mishra, Jain, and Garg 1995
Adiantum sp.	Andesite	Indonesia	Hyvert 1972
Agropyron repens	n.s.	India	Mishra, Jain, and Garg 1995
Albizia lebbeck	n.s.	India	Mishra, Jain, and Garg 1995
Argemone mexicana	n.s.	India	Mishra, Jain, and Garg 1995
Azadirachta indica	n.s.	India	Mishra, Jain, and Garg 1995
Boerhavia diffusa	n.s.	India	Mishra, Jain, and Garg 1995
Calotropis procera	n.s.	India	Mishra, Jain, and Garg 1995
Canscora decurrens	n.s.	India	Shah and Shah 1992-93
Canscora diffusa	n.s.	India	Shah and Shah 1992-93
Cantella asiatica	n.s.	Thailand	Aranyanak 1992
Capparis flavicans	Sandstone	Myanmar	Giantomassi et al. 1993
Capparis horrida	Sandstone	Myanmar	Giantomassi et al. 1993
Cassia accidentalis	n.s.	India	Mishra, Jain, and Garg 1995
Catharanthus roseus	n.s.	Thailand	Aranyanak 1992
Chloris barbata	n.s.	Thailand	Aranyanak 1992
Coccinia indica	n.s.	India	Mishra, Jain, and Garg 1995
Commelina bengalensis	n.s.	Thailand	Aranyanak 1992
Convolvulus sp.	n.s.	India	Mishra, Jain, and Garg 1995
Croton bonplandianum	n.s.	India	Mishra, Jain, and Garg 1995
Cynodon dactylon	n.s.	India, Thailand	Mishra, Jain, and Garg 1995; Aranyanak 1992
Cyperus brevifolius	n.s.	Thailand	Aranyanak 1992
Cyperus rotundus	n.s.	India	Mishra, Jain, and Garg 1995
Dactyloctenium aegyptiacum	n.s.	Thailand	Aranyanak 1992
Dalbergia sisso	n.s.	India	Mishra, Jain, and Garg 1995
Datura sp.	n.s.	India	Mishra, Jain, and Garg 1995
Digitaria adscendens	n.s.	Thailand	Aranyanak 1992
Dryopteris sp.	n.s.	India	Mishra, Jain, and Garg 1995
Eclipta alba	n.s.	India	Mishra, Jain, and Garg 1995
Euphorbia hirta	n.s.	Thailand, India	Aranyanak 1992; Mishra, Jain, and Garg 1995
Euphorbia sp.	Andesite	Indonesia	Hyvert 1972
Ficus bengelensis	n.s.	India	Mishra, Jain, and Garg 1995
Ficus religiosa	n.s.	Thailand, India	Aranyanak 1992; Mishra, Jain, and Garg 1995
Ficus rumphii	Sandstone	Myanmar	Giantomassi et al. 1993
Fleurya interrupta	n.s.	India	Shah and Shah 1992–93
Heliotropium indicum	n.s.	India	Mishra, Jain, and Garg 1995
Holoptelea integrifolia	n.s.	India	Mishra, Jain, and Garg 1995
Imperata cylindrica	n.s.	India	Mishra, Jain, and Garg 1995
Kickxia incana	n.s.	India	Shah and Shah 1992–93
Leucas biflora	n.s.	India	Shah and Shah 1992–93
Lidenbergia indica	n.s.	India	Shah and Shah 1992–93
Lycopodium sp.	Andesite	Indonesia	Hyvert 1972
Mimosa pudica	n.s.	India	Mishra, Jain, and Garg 1995
Nepeta hindostana	n.s.	India	Shah and Shah 1992-93
Nephrolepsis sp.	Andesite	Indonesia	Hyvert 1972
Notochlaena sp.	Andesite	Indonesia	Hyvert 1972
Ophioglossum sp.	Andesite	Indonesia	Hyvert 1972
Oxalis sp.	n.s.	India	Mishra, Jain, and Garg 1995
Physalis minima	n.s.	India	Mishra, Jain, and Garg 1995
Piperomia sp.	Andesite	Indonesia	Hyvert 1972
Pityrogramma sp.	Andesite	Indonesia	Hyvert 1972
Saccharum munja	n.s.	India	Mishra, Jain, and Garg 1995
Sida cardifolia	n.s.	India	Mishra, Jain, and Garg 1995
Solanum nigrum	n.s.	India	Mishra, Jain, and Garg 1995
Trachyspermum stictocarpum	n.s.	India	Shah and Shah 1992–93
Trichodesma amplexicaule	n.s.	India	Shah and Shah 1992--93
Tridax prostala	n.s.	Thailand	Aranyanak 1992
Woodfordia fruitcoae	n.s.	India	Shah and Shah 1992–93
Ziziphus jujuba	n.s.	India	Mishra, Jain, and Garg 1995

n.s. = not specified

Roccardi 1991; Jain, Mishra, and Singh 1993; Mishra, Jain, and Garg 1995). The root exudates—such as carbohydrates, amino acids, amides, tartaric, oxalic, and citric acids—tend to form salts and chelates upon interaction with stone minerals (Winkler 1975; Bech-Anderson 1987; Caneva and Altieri [1988]; Jain, Saxena, and Singh 1991; Jain, Mishra, and Singh 1993; Mishra, Jain, and Garg 1995). In addition, the carbonic acid produced by means of cellular respiration processes can attack mineral particles and may also be a factor in the biodecay of stone (Mishra et al. 1995).

The presence of plants also influences the microclimate of the stone surface by increasing relative humidity and water retention, which favors the growth of other microorganisms. Also in areas of higher atmospheric pollution, the attack of acidic gases could be greater on wet surfaces. However, a change in the microclimate of a stone surface is not necessarily harmful and may actually help protect it against other factors of decay. For instance, leafy cover on a surface reduces the evaporation of moisture and consequently reduces the rate and impact of salt crystallization processes (Honeyborne 1990; Mishra, Jain, and Garg 1995).

Chapter 3

Preventive and Remedial Methods

A review of the literature indicates that research has concentrated on the elimination of microorganisms, with an additional focus on water-repellent and other preservative coatings, both to prevent deterioration and to remedy its effects once it has occurred (Tiano 1987; Richardson 1988; May et al. 1993).

When considering solutions for stone biodeterioration problems, three factors must be considered: the organism, the environment, and the stone surface. The alteration of any one of these can impact the growth of biodeteriogens and thereby biodeterioration. Several preventive and remedial methods have been used in tropical environments for control and eradication of microorganisms on stone monuments. Although one particular method may be sufficient to achieve the desired results, a combination of methods often provides the best results.

Remedial methods are aimed at the direct elimination and control of all biodeteriogens. At present, chemical treatments, mechanical removal, steam cleaning, and low-pressure water washing are the direct means available to eliminate and control the growth of biodeteriogens. The efficacy of the treatments depends on the methods and products chosen, but new growth invariably reoccurs if environmental conditions promoting biological growth are not modified.

Preventive methods, also called indirect methods, include all activities aimed at inhibiting biological attack on stone monuments by modifying, where possible, the environmental conditions and physico-chemical parameters of a stone surface so they become unfavorable for biological growth. The strong dependence of the viability of the biodeteriogen on the environment makes this approach the most effective method for eliminating undesirable growth.

Environmental parameters such as humidity, temperature, and light can be modified in indoor environments, but outdoor interventions to control these factors are rarely feasible and very limited. On the other hand, nutritive factors that are not related to the composition of the stone—such as deposits of organic debris, dirt, pigeon droppings, and the like—can be reduced. It is also possible to alter the physicochemical parameters of the stone surface by applying preservative treatments.

Preventive Methods

Routine maintenance and design solutions

Considering the ethics of monument conservation, it is not possible to alter or change the general design of a monument to eliminate places for accumulation of water and organic debris that provide a favorable, moist environment for biological growth.

Routine preventive measures that control humidity and eliminate causes of dampness in buildings help reduce the extent of development of biological growth and slow its development. Although publications specific to such routine preventive measures have not been found, several references mention such measures as part of the overall conservation process. Measures such as the repair of roofs, gutters, and other water-shedding systems; improvement of drainage systems; and installation of damp proofing to control rising damp all aid in drying the stone masonry, at least partially (Siswowiyanto 1981; Garg, Dhawan, and Agrawal 1988; Ortega-Calvo, Hernandez-Marine, and Saiz-Jimenez 1993; Ashurst and Ashurst 1988).

Higher plants generally grow in the cracks, cavities, and crevices already present in stone monuments. Therefore, frequent vigilant inspections and timely curative measures, such as repointing of open joints and sealing of cracks, will automatically prevent the establishment of plant growth (Mishra, Jain, and Garg 1995).

Installing narrow flashing strips of thin-gauge copper has been shown to have a long-term inhibiting effect on the biological growth on stone walls. The flashing strips are tucked into the length of horizontal joints in the masonry at intervals of approximately one meter. Rain washing over the strips subjects the face of the masonry to a mildly toxic copper-ion wash; however, a light green stain must be anticipated, which makes the system unsuitable in several instances (Brightman and Seaward 1977; Seaward 1974; BRE 1982; Ashurst and Ashurst 1988).

In archaeological sites in tropical regions, where humidity and precipitation levels are high, protective coverings may sometimes be used to reduce excessive dampness or water stagnation.

Sometimes vegetation may be used as a preventive and protective measure in archaeological sites or outdoor environments. Vegetation for landscaping around monuments and sites may help modify the microclimate and thereby impact biological colonization of masonry structures. However, a careful choice of plants is critical to optimize results and minimize risks related to destructive effects of their root systems. Suitably chosen vegetation may lower the water table, minimize evaporation, reduce air salinity and pollution, and reduce erosion (Fosberg 1980; De Marco, Caneva, and Dinelli 1990).

Periodic cleaning of dirt and dust, spores, and seeds

Sources of nutrition for organisms—such as dust, deposits of various organic substances, bird droppings, and unsuitable restoration materials—must be removed from stone surfaces. Periodic cleaning as a

preventive conservation measure is the principal and sometimes only way to prevent and control biological attack in outdoor tropical environments. It has also been found effective in controlling the initial establishment of mosses, lichens, fungi, algae, and higher plants by discouraging the accumulation of wind-borne spores and seeds of plants and their subsequent germination (Hale 1980; Garg, Dhawan, and Agrawal 1988; Kumar 1989; Shah and Shah 1992–93).

Water repellent and consolidant treatments

Synthetic polymers and resins have been used as protective coatings and consolidants in tropical environments (Sengupta 1979; Kumar 1989; Sharma, Kumar, and Sarkar 1989; Kumar and Sharma 1992). Clearly, for microorganisms on stone, such compounds need to be evaluated, particularly in tropical regions, for the ways in which they influence growth—either directly or by the change in the microenvironment they create (Griffin, Indictor, and Koestler 1991; Krumbein et al. 1993).

In recent studies of preservation treatments, various protective coatings have been screened for microbial susceptibility in the laboratory before being applied to stone in the field (Koestler and Santoro 1988; Nugari and Priori 1985; Krumbein et al. 1993). It has been acknowledged that, in general, most of these experiments with stone consolidants and hydrophobic substances provide only a means of comparing the efficacy of such coatings. The tests are usually very severe in that they provide optimal conditions for growth of microorganisms and may not be truly representative of field conditions. Therefore, when interpreting data from such laboratory studies, extrapolation to practice must not be made until full correlation from field trials is possible (Grant and Bravery 1985a; Krumbein et al. 1993).

The results of most laboratory studies indicate that some of these water repellents and consolidants—including organosilanes, silicones, acrylics, epoxies, and polyvinyl acetates—appear to have practically no effect on the growth of microorganisms on stone and that, on the contrary, some of them could be a source of nutrients for microorganisms (Price 1975; Bradley 1985; Richardson 1988; Salvadori and Nugari 1988; Santoro and Koestler 1991; Krumbein et al. 1993). However, some such substances appear to resist microbial growth, possibly due to the presence of additives (such as dibutyltin dilaurate) that have biocidal characteristics or due to the addition of toxic solvents (Koestler et al. 1987; Koestler and Santoro 1988; Mamonova et al. [1988]).

Field experience has suggested that since growth of microorganisms is usually associated with moisture retention, certain water repellents may be used to increase the effective life of a biocidal treatment and inhibit growth on clean surfaces. These treatments work more effectively when applied to new stone or to clean stone that has already been treated with a biocide. For instance, it was found that applying 2% polymethyl methacrylate solution in toluene to sandstone after a wet cleaning and biocidal treatment was effective in inhibiting biological growth for at least five years on several monuments in India (Lal [1978]; Sharma [1978]; Sharma, Kumar, and Sarkar 1989; Kumar and Sharma

1992). It is also important to remember that water-repellent treatments should never be applied to surfaces that are subject to internal wetting, for example, from rising damp, as there is a danger that salt crystallization may occur beneath the treated surface, causing it to spall (Richardson 1973a, Garg, Dhawan, and Agrawal 1988).

Remedial Methods

Cleaning of stone surfaces

Partially removing biological growth before applying biocidal agents is usually recommended, particularly where stone structures become encrusted with thick cushions of mosses, heavy lichen, and algal growth over a protracted period of time. This procedure hastens biocidal activity by allowing better penetration (Richardson 1973a; BRE 1982; Garg, Dhawan, and Agrawal 1988).

Traditionally, conservators have favored mechanical methods for removing biological growth, as they eliminate the danger of leaving behind unwanted substances on the stone. These methods involve physically removing biological material by hand or with tools such as stiff bristle or nonferrous soft-wire brushes, scalpels, spatulas, scrapers, sickles, pick axes, or hoes. For trees and creepers that attach themselves to the surface of monuments with suckers and tendrils, it may be necessary to cut the length of the main stem at a convenient height above ground level. The plant may then be left in this state to die of its own accord, or a toxic material may be applied to hasten its destruction.

The literature is full of references to such measures as part of overall conservation efforts to restore stone monuments and sites. Although frequently used, these methods have not produced long-lasting results, as removal of superficial mycelium or cutting of vegetation alone does not completely arrest vegetative activity of these organisms. Algae may redevelop from airborne spores, lichen hyphae remaining within the stone may produce a new thallus, and plants may resprout rather rapidly when suitable environmental conditions exist (Richardson 1973a; Mishra, Jain, and Garg 1995). To completely eradicate biological growth, the operation must be repeated from time to time. Moreover, there is always the danger that such methods may damage a stone surface.

Microorganisms associated with the visual disfigurement of monuments can be gently removed mechanically by dry or wet scrubbing or brushing, and washing with water. Brushing and washing with water have been found effective for some algae, spermatophytes, and pteridophytes but mostly ineffective for mosses and crustose lichens. Mosses and lichens may be more easily removed by low-pressure washing and/or after the application of certain chemicals that destroy them (Siswowiyanto 1981; Garg, Dhawan, and Agrawal 1988; Sadirin [1988]; Ashurst 1994).

Algae, which die from lack of moisture, may easily be removed by low-pressure water rinsing prior to general cleaning. Steam cleaning may also be useful in killing mold and algae on damp surfaces.

However, it must be remembered that water introduced during cleaning processes may actually encourage rapid algal regrowth (Richardson 1973a; Garg, Dhawan, and Agrawal 1988; May et al. 1993; Ashurst and Ashurst 1988). Hence, the effectiveness of all cleaning methods involving large quantities of water must be carefully assessed in relation to microbial loading, as it has been found that such treatments reduce the amount of infestation only for a relatively short time (Warscheid, Petersen, and Krumbein 1988). This problem may be avoided by applying a biocidal treatment after water cleaning.

Prior application of dilute ammonia has often been recommended to facilitate the mechanical removal of lichens on stone, as it assists in the swelling and softening of the thalli (Sneyers and Henau 1968). Literature indicates that 2–5% aqueous ammonia has been found to be very effective in cleaning the stone monuments in India that were covered with mosses, lichens, algae, and fungi without creating any side effects. This cleaning is usually followed by a biocidal treatment to inhibit biological growth and a water-repellent or preservative treatment to act as a water barrier (Lal [1978]; Sharma [1978]; Sengupta 1979; Sharma et al. 1985; Kumar 1989).

Siswowiyanto (1981) and Sadirin ([1988]) mention the use of a poultice based on the chelating agent ethylenediaminetetraacetic acid (EDTA) to remove biological growth on stone monuments in Borobudur. This gelatinous solvent paste is known as AC 322 in Indonesia and AB 57 in Europe and the United States. It is composed of a mixture of sodium and ammonium bicarbonates, EDTA, carboxymethyl cellulose, a detergent, and sometimes a disinfectant (Garg, Dhawan, and Agrawal 1988; Caneva, Nugari, and Salvadori 1991; Ashurst and Ashurst 1988).

The use of diluted solutions of hydrogen peroxide and sodium hypochlorite to clean algae on stone surfaces has also been widely reported (Spry 1981; Garg, Dhawan, and Agrawal 1988; Caneva, Nugari, and Salvadori 1991). The bleaching action of these solutions on stone must, however, be carefully evaluated (Nugari, D'Urbano, and Salvadori 1993).

Evaluation of chemical cleaning processes usually indicates a six- to eight-month delay in reappearance of microbial growth in the absence of subsequent application of any biocidal or preservative treatment (Bettini and Villa 1981).

Biocidal treatments

Biocides refer collectively to bactericides, fungicides, algicides, and herbicides. They are frequently used to eliminate and inhibit biological growth. Several studies exist on the effect of biocides on the activity and growth of microorganisms on stone in tropical regions (Fusey and Hyvert 1966; Gairola 1968; Lal [1978]; Nagpal 1974; Hale 1980; Siswowiyanto 1981; Sharma et al. 1985; Richardson 1988; Garg, Dhawan, and Agrawal 1988; Sharma, Kumar, and Sarkar 1989; Kumar and Sharma 1992; Mishra, Jain, and Garg 1995). Biocides may inhibit the metabolic activity of target organisms, thereby causing irreparable damage and even death (Denyer 1990).

Numerous studies have tested the effects of biocides on microbial growth on stone (BRE 1982; Tiano 1979; Bassi, Barbieri, and Bonecchi 1984; Sharma et al. 1985; Richardson 1988, Grant and Bravery 1985b). Several authors have developed laboratory testing methods that evaluate the effectiveness of biocides on different organisms and stone surfaces (Grant and Bravery 1981a, 1981b, 1985a, 1985b; Koestler and Santoro 1988; Krumbein and Gross 1992, Lisi et al. 1992; Nugari, D'Urbano, and Salvadori 1993). Grant and Bravery (1981a) reviewed the range of test methods for assessing the effectiveness of biocides in stone conservation and suggested a new technique that allows for a more realistic simulation of in situ conditions.

After twenty years of research on biocides, Richardson (1973a, 1976, 1988) found that biocidal activity appears to be most strongly developed in surface-active quaternary compounds. These compounds are effective against most microorganisms on stone monuments. Dawson (1982) states that they are effective against gram-positive bacteria but not against gram-negative bacteria. The most effective eradicant with persistent inhibitory action was observed to be tributyltin oxide emulsified with quaternary ammonium compounds (Richardson 1988); however, the use of organotin compounds is not acceptable in many countries because of their high toxicity.

Application of aqueous solutions of benzalkonium chloride (20%), sodium hypochlorite (13%), and formaldehyde (5%), using soaked cotton strips for about 16 hours, followed by scrubbing with a brush and water, effectively killed lichens on stone (Nishiura and Ebisawa 1992). A quaternary ammonium compound (Hyamine 3500) applied on sandstone monuments after chemical cleaning has effectively inhibited microbial growth (Siswowiyanto 1981; Sadirin [1988]). However, this treatment is known to provide only temporary inhibition, suggesting that periodic treatment is required to prevent reinfestation, particularly in tropical environments, where environmental conditions promote rapid biological growth.

Polybor (a mixture of polyborates and boric acid) has been found effective on stone in field trials in tropical environments without any noticeable adverse effects. Although its eradicant action is not rapid, its inhibitory action on algal growth lasts for at least two or three years and substantially longer on mosses and lichens (Richardson 1976, 1988). Hale (1980) used borax and Clorox on Maya ruins in two or three successive treatments to completely eradicate microbial growth. As it is impossible to eliminate the natural sources of these microscopic, windborne spores, Hale suggested that the biocide be sprayed at least every year to control the biological growth.

Sodium salts of pentachlorophenol (Richardson 1973a; Kumar 1989; Cepero 1990) have been investigated for their ability to eradicate or inhibit biological growth on stone. Sodium pentachlorophenate (2%) was not found to be very effective in field trials. It could prevent microbial growth only for six to twelve months (Kumar 1989). Besides, these treatments are toxic and may stain light-colored stone by reacting with the iron of the stone surface. Further, the introduction of

alkali metal salts in stone will produce soluble salts that may cause crystallization damage (Richardson 1988).

Copper compounds have residual effects and may remain longer on stone surfaces than other biocides. The drawback with these compounds is that they stain the stone surface. Copper sulfate, which is frequently used as a biocide, is much more effective against algae and fungi than bacteria (Salle 1977; Richardson 1988; Ware 1978; Dawson 1982; Cepero et al. 1992; Shah and Shah 1992–93). However, a literature search showed no evaluations of copper compounds on stone monuments in tropical environments.

A recent review of biocides used to control lichens on building materials showed that treatments containing copper had the greatest potential for controlling lichen growth (Martin and Johnson 1992), although some lichens were capable of growing on substrates containing high concentrations of copper (Alstrup and Hansen 1977; Gilbert 1977; Jahns 1973; James 1973; Purvis, Gilbert, and James 1985; Martin and Johnson 1992).

The application of zinc hexafluosilicates, followed by a treatment with a dilute solution of a moisture barrier such as acrylics or PVA, has been used effectively to inhibit microbial growth on several stone monuments in India. This treatment was found to be effective for at least four or five years (Gairola 1968; Nagpal 1974; Lal 1970, 1978; Sharma [1978]; Kumar, 1989; Sharma, Kumar, and Sarkar 1989; Kumar and Sharma 1992; Cepero et al. 1992; Shah and Shah 1992–93).

Mercurial compounds have also been found to be effective in eradicating microorganisms, although their action was relatively transient (Richardson 1988; Shah and Shah 1992–93). Their use has been discontinued because of their high toxicity and instability under the rather extreme conditions existing on stone surfaces.

Chapter 4

Selection of Chemical Treatments

Some Considerations in Biocide Selection

While the term *biocide* pertains to any chemical able to kill or inhibit the growth of living organisms, it is most commonly used with regard to microorganisms and higher plants. These chemicals, however, are also potentially harmful to wildlife and humans. For this reason, there is a mandatory need to identify and disclose the toxicological properties of biocides and to perform a risk assessment for each specific biocide application.

When considering biocides for controlling and eradicating biological growth on stone monuments, several factors, such as efficiency against target organisms, resistance of target organisms, toxicity to humans, risks of environmental pollution, compatibility with stone, and effects of interactions with other chemical conservation treatments, need to be discussed (Dawson 1982; Caneva, Nugari, and Salvadori 1991; Krumbein et al. 1993; May et al. 1993; Wakefield and Jones 1996).

Efficiency against target organisms

Biocide efficiency generally refers to its ability to effectively kill or inhibit growth of target organisms. The first step in choosing a biocide for stone should be to identify the biodeteriorating agents as accurately as possible. Often biocides tend to be more efficient on some organisms than others. Efficiency depends on the type of biocide and the conditions under which it is applied. Parameters such as temperature, rainfall, pH, relationship between concentration and activity, and contaminants, which determine the effectiveness of a biocide, must be carefully considered.

Biocides with a wide spectrum of action against most target organisms and persistent activity seem most suitable for inhibiting organism colonization (Dawson 1982; Agarossi et al. [1988]; Caneva, Nugari, and Salvadori 1991). At present, there are few compounds that are equally efficient in eradicating all types of biodeteriogens. Although a residual biocide with persistence activity is advantageous with regard to long-term inhibition of biological growth, it may be a potential public health and environmental hazard.

Resistance of target organisms

Resistance—which is the natural or genetic ability of an organism to tolerate the toxicity of chemicals—is a very important consideration in the effective use of biocides. Some organisms, especially bacteria, can develop resistance to a particular biocide over a period of time. It then becomes necessary to apply a different biocide, which may prove more effective against growth. This biocide must be compatible with the previously applied biocide, and this can be assessed only experimentally. Identification of microorganisms is important in making the choice of the subsequent biocide (Ware 1978; Dawson 1982). Rotation of biocidal products may help avoid the development of resistant strains of microorganisms (Caneva, Nugari, and Salvadori 1991).

Studies also indicate that eliminating a particular species of microorganism may result in the increase or development of more resistant organisms on the stone substrate. This is especially true of bacteria, which have been shown to increase in numbers after effective control of fungi and actinomycetes with biocides has occurred (Agarossi et al. [1988]; May et al. 1993).

Toxicity to humans

Before using a biocide on stone surfaces, one should be aware of not only its toxicity to biological growth but also its toxicity to humans. Such information can be obtained from the manufacturer, appropriate government regulatory agencies, or toxicology sourcebooks. In the United States, this information is provided on the Materials Safety Data Sheets obtainable from the manufacturer. Interestingly, most biocide formulations are not an industry secret because federal regulations require biocide ingredients, toxicological category, as well as handling instructions to be listed on shipping containers.

The literature describes several parameters that define the toxicity of a compound (Gangstad 1982; Caneva, Nugari, and Salvadori 1991; Casarett, Amdur, and Klaassen 1995). The most common indices for quantifying toxicity are LD_{50} and LC_{50} values. LD_{50} is an abbreviation for Lethal Dose 50% and is the most common measure of acute or short-term, single-exposure toxicity for a particular substance. It is essentially the amount of active substance that can be expected to cause death in half (50%) of a group of a particular experimental animal species, such as rats or rabbits, when entering their bodies orally or through dermal exposure (e.g., sodium pentachlorophenate oral $LD_{50r} = 180$ mg kg^{+1}, where r = rat). The amount required to kill individual animals is related to their body weight. Therefore, LD_{50} figures are usually reported as units of milligrams of the substance per kilogram body weight of the animal species concerned.

LC_{50} (Lethal Concentration 50%) is a similar and a widely used measure of chronic toxicity or long-term exposure to a gaseous substance through inhalation over a specified period of time. LC_{50} figures are usually reported as milligrams of a substance per cubic meter of the atmosphere to which the animal is exposed over a particular time period.

From the foregoing, it is clear that the higher the LD_{50} or LC_{50} value, the lower the toxicity of the substance. However, it requires expert judgment to assess the relevance of toxicity data derived from animals to humans. Ideally, biocides used in the field of stone conservation should have high LD_{50} or LC_{50} values. They should be toxic to target organisms but neither pose health hazards to those applying them nor introduce other environmental hazards.

On the basis of the LD_{50} and LC_{50} values, public health agencies have assigned various toxic hazard categories to substances in decreasing order of human risk. Substances are considered extremely toxic when oral LD_{50} value is between 0 and 50, dermal LD_{50} value is between 0 and 200, and inhalation LC_{50} value is between 0 and 2000. They are moderately toxic when oral LD_{50} value is between 50 and 500, dermal LD_{50} value is between 200 and 2000; and inhalation LC50 value is between 2000 and 20,000. The category "slightly toxic to relatively nontoxic" is assigned to substances with an oral LD_{50} value greater than 500, dermal LD_{50} value greater than 2000, and inhalation LC_{50} value greater than 20,000. These figures may vary somewhat in different countries. This could be one of the reasons why some substances, such as organotin compounds, are prohibited by law in some countries, whereas their use is permitted in other places.

Risks of environmental pollution

As a result of an increasing interest in the conservation of the environment, apprehension regarding the risks of environmental pollution from the use of biocides has grown. Considerable information on this subject can be found in the literature, particularly in the fields of agriculture, ecology, hydrology, health, and environmental science. The risks from biocides are linked to factors such as drift and undesirable effects on nontarget microflora, plant, animal, and aquatic life. The problem is especially relevant where the risk of contamination of soil and water is high. This is correlated with the chemistry of the soil, its moisture content, the pH, the climate, particularly wind conditions, and present flora and fauna. To protect nontarget species from injury and extermination due to direct or indirect exposure to these toxic substances, federal environmental protection agencies in different countries have established different standards for their use, handling, and disposal.

Compatibility with stone and other conservation treatments

A biocide should be compatible with the surface on which it is applied. It should not alter the nature, composition, and appearance of stone.

Biocides have typically been formulated for use in other areas where biological control is necessary, for example, agriculture, medicine, and offshore industry. Very few formulations have been designed specifically for application on stone or other valuable cultural materials. Consequently, the effects of such chemicals on stone has largely been ignored at the manufacturing level (Wakefield and Jones 1996); however, in recent years there has been increasing concern for the potential of biocides to cause stone decay.

Some of the chemical ingredients in the biocide may interact with stone minerals, thereby affecting the stone's durability. Studies of effects of biocides on stone have shown that some of these substances may cause etching and dissolution of stone minerals and result in color change and salt crystallization damage (Richardson 1973a, 1976, 1988; Lisi et al. 1992; Nugari, D'Urbano, and Salvadori 1993; Nugari, Pallecchi, and Pinna 1993; Ashurst and Ashurst 1988). For instance, treatments with a sodium salt of phenol suffer from the serious disadvantage that they may cause staining in some stones through the reaction of the alkali phenol with iron in the substrate (Richardson 1973a, 1976, 1988).

It has also been found that the efficacy of biocides in killing target organisms is usually not the same on different stone substrates, as surface conditions and stone mineralogy often affect biocidal activity (Grant and Bravery 1981a; Wakefield and Jones 1996).

The use of different biocides to avoid growth of resistant species requires careful study. Such research should consider problems of compatibility with other conservation treatments and collateral effects of interactions between the chemicals, even if they are applied at different times. Undesirable chemical reactivity of the biocide may not only cause aesthetic damage but also render any or all other conservation treatments useless (Caneva, Nugari, and Salvadori 1991; Nugari, D'Urbano, and Salvadori 1993).

Biocide Application: Procedures and Precautions

Biocides may be washed out by rain before they have had time to act. Biocidal treatments should therefore be undertaken during dry conditions. Windy weather may lead to excessive drift of biocidal spray and pose health and environmental hazards.

In some instances, depending on the type of growth, at least partial removal (mechanical or manual) of the biomass may be necessary before the biocide can be applied. Heavy encrustations of lichens and mosses, and established plant life, may not allow sufficient penetration of the biocide to the stone surface (Ramchandran 1953; Lal 1962–63; Richardson 1973a). On the other hand, when biological encrustations are not very heavy, prior cleaning may not be necessary. Certain biocides not only kill biological organisms, they also prevent subsequent water absorption, causing the existing growth to become dry and brittle. Dry growth may eventually crumble and fall away naturally through the action of wind and rain after six to twenty-four months of treatment, depending on the site conditions and species involved. Light brushing and mechanical cleaning may hasten the process (Richardson 1973a, 1988; Garg, Dhawan, and Agrawal 1988; Hale 1980).

The solution of an appropriately chosen biocide must then be carefully prepared and applied in strict accordance with the manufacturer's recommendations for safety and protection of operator and the environment. Details of rates, modes, timing of application, and other factors are available from the manufacturers. When handling and

mixing biocides, one must remember to always wear rubber gloves, safety glasses, and a respirator. Only the required quantities of diluted biocides should be prepared, as their effectiveness may be reduced when they are stored for a long time (Ashurst and Ashurst 1988; Mishra, Jain, and Garg 1995).

Adequate care must always be taken to protect the vegetation in the area surrounding monuments. To avoid the hazardous effects of spillage, protective sheets must be laid over plants and the ground before biocide application. In areas close to bodies of water, it may be prudent to perform only mechanical cleaning during and after treatment to avoid contamination caused by leaching of biocide from the treated surfaces.

Depending on the state of conservation of the stone, the organisms to be eliminated, the density and diffusion of biological attack and product chosen, treatments may be carried out by spraying, brushing, applying poultices, or injection. Some references and case studies of biocidal treatments on stone monuments mention not only the mode of application but also the reasons for the choice.

Worldwide spraying and brushing of diluted biocidal solutions appear to be the most common modes of application. Brushing is recommended when the stone surface is in fairly good condition and the area required to be treated is relatively small. Spraying is the preferred choice for deteriorated stone surfaces.

Diluted biocidal solutions may be applied with a pneumatic garden-type sprayer with adjustable nozzles, preferably two-thirds full of the diluted biocides. After pumping the container, solution pressure and droplet size should be such that the spray saturates the surface of the masonry without causing excessive bounce back and spray drift (Richardson 1976; Ashurst and Ashurst 1988; Mishra, Jain, and Garg 1995).

Spray application usually should commence at the top of the vertical surface to be treated and move horizontally and slowly to allow rundown. The next horizontal pass should be made across the previous rundown (Richardson 1976). To successfully inhibit biological growth, repeated application cycles may be required for certain biocides (Garg, Dhawan, and Agrawal 1988).

For taller plants—such as perennial, herbaceous, and woody species of weeds—spot spraying or brushing is usually the best approach. Brush or spray application of biocides on stumps of herbaceous and woody species of plants prevents resprouting and hastens their destruction. Biocides are applied in sufficient quantities to wet the top and sides of the stumps (Ashurst and Ashurst 1988; Mishra, Jain, and Garg 1995).

In several instances, holes have been drilled into the stumps of trees and bushes in order to facilitate injection of biocidal solution (Peevy 1972a, 1972b; Meyer and Bovey 1973; Caneva, Nugari, and Salvadori 1991; Giantomassi et al. 1993; Mishra, Jain, and Garg 1995).

Diluted solution of biocides has also been applied in cellulose poultices, especially in the case of hard encrustations, to increase contact time and make use of the dissolving action of water itself. These poultices have usually been covered with sheets of polyethylene to reduce

evaporation. Sometimes the chosen biocides have been added to a gelatinous solvent paste called AC 322 (AB 57 in the United States and Europe), widely used for cleaning of stone, as described in the previous chapter (Siswowiyanto 1981; Sadirin [1988]; Garg, Dhawan, and Agrawal 1988).

In cases where two biocides have been used to completely eradicate biological growth, the area treated after one biocide application is left for at least one week to effect the initial kill. The dead biological growth can then be brushed off with bristle brushes. With more persistent biological activity, a second biocide may be applied according to manufacturer's specification to inhibit biological growth successfully (Garg, Dhawan, and Agrawal 1988).

Great care must be taken during the removal of dead plants and well-established mats of vegetation from stone surfaces after biocidal application. Mature growth must be carefully cut or pulled out at every joint. The wedging of stone blocks, tamping, grouting, pointing, and resetting of stones—especially on wall tops—all need to be anticipated as part of the followup remedial work (Giantomassi et al. 1993; Ashurst and Ashurst 1988; Mishra, Jain, and Garg 1995).

Chemical Treatments Used to Control Biodeteriogens

Relevant information on commercially available biocides used to control microbiological growth on building materials is summarized in Table 4.1 from several references mentioned in this book and a list of biocides compiled by Allsopp and Allsopp (1983); Garg, Dhawan, and Agrawal (1988); and Martin and Johnson (1992). Some of these chemicals have not been tested on stone in tropical regions. Chemicals that have been used in the past in tropical regions are marked in the table.

Biocides are listed on the basis of their chemistry and are identified by their chemical name. The trade names of compounds and their manufacturers are mentioned in a separate column if they have been specified in literature. Oral lethal doses LD_{50r} for rats are also given. These values are not sufficiently useful in determining the toxicity of the compound to humans, but they are useful for having a general idea of hazard in the use of the products.

Chemicals used for cleaning biological growth and preservative treatments, such as water repellents and consolidants, that were used specifically to inhibit biological growth by enhancing the residual effect of biocides are listed in Tables 4.2 and 4.3. (The information provided in Tables 4.1, 4.2, and 4.3 is based primarily on data reported on the use of products in the conservation field and may be incomplete.)

Table 4.1 Chemicals used as biocides to remove or control the growth of microorganisms on building materials

Chemicals used as biocides	Trade name (Manufacturer)	Toxicity data	Organisms targeted	Surface	Method of application	Effectiveness of treatment	References
Boron compounds							
Disodium octaborate tetrahydrate (4–5% aqueous solution)	Polybor (ICI Chemicals)	LD_{50r} = 2000 mg/kg	Fungi, algae, lichens, and mosses	Stone	Low-pressure spray application	Provides freedom from algae for 2.5 years and from moss and lichens for a substantially longer period	Richardson 1973b, 1976, 1988; Brown and Souprounovich 1989
Copper compounds							
Copper sulfate[a] (4% aqueous solution)	—	LD_{50r} = 300 mg/kg	Algae and lichens	Concrete and terra-cotta	Brush or spray application	Residual effect that prevents biological growth for several years	Division of Building Research, CSIRO 1977; Shah and Shah 1992–93
Copper nitrate[a] (3–5% aqueous solution)	—	LD_{50r} = 940 mg/kg	Algae and lichens	Stone	Spray application	Relatively transient eradicant action	Garg, Dhawan, and Agrawal 1988; Shah and Shah 1992–93
Copper-8-hydroxy quinolinolate[a] (1–5% aqueous solution)	—	LD_{50m} = 67 mg/kg	Algae and lichens	Buildings	Spray application	Kills biological growth in five months	Lloyd 1972
Copper carbonate + Ammonia + water (1:10:170)	—	LD_{50r} = 159 mg/kg	Algae and lichens	Buildings	Brush application after cleaning	Prevents growth for 2–3 years, but on dense surfaces annual treatment may be necessary	BRE 1982
Magnesium compounds							
Magnesium fluosilicate[a] (0.5–5% aqueous solution)	—	LD_{50}[a] = 200 mg/kg [a](guinea pig)	Fungi, algae, lichens, and mosses	Stone and concrete	Brush application	Effective with wide range of organic growth; relatively transient eradicant	BRE 1982; Tanner et al. 1975; Richardson 1988
Zinc compounds							
Zinc fluosilicate[a] (1–2% aqueous solution)	—	LD_{50r} = 100 mg/kg	Fungi, algae, lichens, and mosses	Stone	Spray application after cleaning with ammonia	Residual effect that prevents biological growth for 3–5 years	Gairola 1968; Plenderleith 1968; Schaffer 1972; Clarke 1978; BRE 1982; Cepero 1990; Kumar and Sharma 1992
Aldehydes							
Formaldehyde[e] (2–5 % solution)	Formalin (Sigma)	LD_{50r} = 800 mg/kg	Fungi, algae, lichens, and mosses	Stone and concrete	Mostly spray application, but sometimes brush application	Kills organisms, but does not have residual effect to prevent further colonization	BRE 1982; Keen 1976; Fielden 1982
Esters							
Ethyl ester of p-hydroxybenzoic acid	Aseptine-A (Synteza Chemical)	n.s.[b]	Fungi, algae, and lichens	Stone	Brush application	Very effective in preventing biological growth for more than two years	Leznicka 1992

(continued on next page)

Table 4.1 *continued*

Chemicals used as biocides	Trade name (Manufacturer)	Toxicity data	Organisms targeted	Surface	Method of application	Effectiveness of treatment	References
Methyl ester of p-hydroxybenzoic acid	Aseptine-M (Synteza Chemical)	n.s.[b]	Fungi, algae, lichens, and mosses	Stone	Brush application	Effective for fast disinfecting; long-term effectiveness is not known	Leznicka 1992
Phenolic compounds 5,5'-dichloro-2,2'-dihydroxy diphenylmethane (1–4% aqueous solution)	Dichlorophen (Ward Blenkinsop)	$LD_{50r} =$ 2690 mg/kg	Algae, lichens, and mosses	Stone and Concrete	Brush application	Eliminates existing growth and has sufficient residual effect to prevent further colonization	BRE 1982; Keen 1976; Clarke 1978
Chlorinated phenolic compound	Thaltox C (Wykamol Ltd.)	n.s.[b]	Algae, lichens, and mosses	Buildings	Spray application	Effective for 2–3 years; may require retreatment at the beginning of each rainy season	BRE 1982
Chlorinated phenolic compound with other active ingredients	Halophane (Winton Chemicals Ltd.)	n.s.[b]	Bacteria, algae, lichens, and mosses	Buildings	Spray application	Effective for 2–3 years	BRE 1982
o-Phenyl phenol in an aromatic organic solvent (2%) + silicone-resin masonry water repellent (5%)[a]	—	n.s.[b]	Algae, lichens, and mosses	Concrete	Brush application	Effective	Keen 1976
Pentachlorophenol + ammonium sulfate (5% aqueous solution)	—	n.s.[b]	Lichens	n.s.[b]	Spray or brush application	Kills lichens in 6 weeks to 5 months	Lloyd 1972
Pentachlorophenol + 2,4,6-trichlorophenoxy-1-isopropanol (1% alcoholic or aqueous)	—	n.s.[b]	Lichens	Cemented wall	Spray or brush application	Kills lichens in 6 weeks to 5 months	Lloyd 1972
Pentachlorophenyl laurate (14.7%) + cetyl pyridinium bromide (3%) + p-chloro-m-cresol (1.55%)	Mystox QL (Catomance Ltd.)	$LD_{50r} =$ 2000 mg/kg	Algae, lichens, and mosses	Stone	Spray application	Effective relatively long-term	BRE 1982; Garg, Dhawan, and Agrawal 1988
Phenola (5% aqueous solution)	—	$LD_{50r} =$ 530 mg/kg	Lichens, mosses, algae, and fungi	Buildings	Spray application	Effective, but too hazardous, carcinogenic, and unpleasant	BRE 1982
Sodium o-phenyl phenate (1–2.5 % solution)	—	$LD_{50r} =$ 2500 mg/kg	Lichens, algae, and mosses	Concrete	Brush application preferred; low-pressure spray application possible	Eliminates existing growth; regrowth occurs if conditions of dampness arise again	Keen 1976

Sodium pentachloro-phenate (1–2 % solution)	—	LD_{50r} = 180 mg/kg	Lichens, algae, fungi, and mosses	Stone	Spray application	Effective long-term with some degree of persistency	BRE 1982; Sneyers and Henau 1968; Kumar 1989; Cepero 1990
Sodium salt of phenol such as pentachlorophenol or o-phenylphenol + sodium methyl siliconate	—	n.s.[b]	Lichens, mosses, algae, and fungi	Stone	Brush application	Very effective	Richardson 1973a
Quaternary ammonium compounds							
Alkyl benzyl trimethyl ammonium chloride (1% solution)	Gloquat C[a] (ABM Chemicals)	LD_{50r} = variable	Lichens, mosses, and algae	Stone	Low-pressure spray application	Effective in killing and inhibiting growth 2–3 years	Richardson 1973a, 1973b; Wright 1986
Alkyl benzyl trimethyl ammonium chloride + alkyl benzyl dimethyl ammonium chloride[a]	—	LD_{50r} = 240 mg/kg	Algae, lichens, and mosses	Stone	Low-pressure spray application	Kills growth in 2 weeks; does not have long-term effectiveness	Richardson 1976
Alkyl benzyl dimethyl ammonium chloride	Hyamine 3500[a] (Rohm and Haas) Preventol R50, R80, R90 (Bayer)	LD_{50r} = 240 mg/kg	Bacteria, fungi, algae, and lichens	Stone	Spray application	Effective in eradication; long-term effectiveness is not known	Siswowiyanto 1981; Sharma et al. 1985; Caneva, Nugari, and Salvadori 1991; Lisi et al. 1992
Di α (p-tolyl)-dodecyl-trimethylammonium methoxy sulfate	Desogen (Ciba Geigy)	n.s.[b]	Bacteria and fungi	Stone	Brush application	Effective	Lisi et al. 1992
Diisobutyl phenoxy ethoxy ethyl dimethyl benzyl ammonium chloride	Hyamine 1622[a] (Rohm and Haas)	LD_{50r} = 420 mg/kg	Algae	Stone	Brush application	Effective	Siswowiyanto 1981
Methyldodecyl benzyl trimethyl ammonium chloride (40%) + methyldodecyl xylylene-bis-(trimethyl ammonium chloride)(10%)	Hyamine 2389[a] (Rohm and Haas)	LD_{50r} = 389±28 mg/kg	Algae	Stone	Brush application	Effective	Garg, Dhawan, and Agrawal 1988
Salicylate Compounds							
Dodecylamine salicylate (1–5% aqueous solution)	Nuodex 87 (Durham Chemicals)	LD_{50r} = 2000 mg/kg	Algae and lichens	Buildings	Brush or spray application	Effective for 2–3 years	BRE 1982; Frey et al. 1993
Salicylanilide (1–2% aqueous solution)	—	LD_{50r} = 5000 mg/kg	Fungi, algae, lichens, and mosses	Buildings	Spray application	Destroys growth, but needs periodic retreatment	BRE 1982

(continued on next page)

Table 4.1 *continued*

Chemicals used as biocides	Trade name (Manufacturer)	Toxicity data	Organisms targeted	Surface	Method of application	Effectiveness of treatment	References
Sodium salicylate (1% aqueous solution)	—	n.s.[b]	Algae, lichens, and mosses	Stone	Spray application after cleaning with dilute ammonia	Effective, but needs periodic retreatment	Sneyers and Henau 1968
Sodium salt of salicylanilide (1% aqueous solution)	—	n.s.[b]	Fungi, algae, lichens, and mosses	Buildings	Brush or spray application	Effective	BRE 1982; Clarke 1976
Compounds containing nitrogen and sulfur							
2-terbutylamine-4-ethylamine-6 methyl-S-triazine	Terbutrin (n.s.[b])	LD$_{50r}$ = 2400–2980 mg/kg	Algae and lichens	Stone	Brush application	Effective for more than a year	Giacobini and Bettini [1978]; Tiano 1979
3-(3-trifluoromethylphenyl) 1,1-dimethyl urea (3% aqueous solution)	Fluometuron or Lito 3 (Ciba Geigy)	LD$_{50r}$ = 6416–8000 mg/kg	Algae, lichens and mosses	Sandstone, limestone, and marble	Brush application, repeated after 60–90 days	Effective for 6 months	Giacobini and Bettini [1978]; Bettini and Villa 1981
3-(4-Bromo, 3-chlorophenyl) 1-methoxy-1 methyl urea	Chlorobromuron (n.s.[b])	LD$_{50r}$ = 2150 mg/kg	Algae and lichens	Marble, travertine, tuff, and basalt	Brush or poultice application	Effective for 2–22 months	Giacobini and Bettini [1978]; Tiano 1979
Organotin and Organotin with quaternary ammonium compounds							
Tributyltin oxide (1% solution)	TBTO (Merck) Thaltox (Wykamol Ltd.)	LD$_{50r}$ = 87–200 mg/kg	Lichens	Granite	Brush application	Effective for three years	Clarke 1978
Tributyltin oxide (0.5%) + alkyl benzyl dimethyl ammonium chloride (2%)	—	n.s.[b]	Lichens	Buildings	Low-pressure spray application	Effective long-term; takes 3–12 months to eradicate lichens; recolonization occurs after 6 years	Brown and Souprounovich 1989
Tributyltin oxide + quaternary ammonium compound	Thaltox Q[a] or Murasol 20 (Wykamol Ltd.)	LD$_{50r}$ = 500–1000 mg/kg	Fungi, algae, lichens, and mosses	Stone	Brush or spray application	Effective long-term	Richardson 1973a, 1973b, 1976, 1988; Ashurst 1975; BRE 1975; Fry 1985
Tributyltin oxide + silicone water repellent	—	LD$_{50r}$ = 87–200 mg/kg	Fungi, algae, lichens, and mosses	Stone	Brush application	Effective eradicant; no information on long-term effectiveness	Dukes 1972
Tributyltin oxide[a] emulsified with alkyl benzyl trimethyl ammonium chloride	—	n.s.[b]	Fungi, algae, lichens, and mosses	Stone and concrete	Brush application	Very effective eradicant with persistent inhibitory action	Richardson 1988
Tributyltin naphthenate	Mergal HS 21 (Hoechst)	LD$_{50r}$ = 224 mg/kg	Bacteria and fungi	Stone	Brush application	Effective	Krumbein and Gross 1992

Miscellaneous compounds

4-chloro o-tolyloxyacetic acid	—	LD_{50r} = 700–800 mg/kg	Lichens	Sandstone	Spray application	Severe damage to lichens, but ineffective after a year	Gilbert 1977
An amine based compound (10% aqueous solution)	Chlorea (ICI Chemicals)	n.s.[b]	Lichens	Granite	Brush or spray application	Within two hours lichens curled up, discolored, and could be brushed off; effective for one year	Clarke 1978
Lithium salt of bromacil + benzyl alkyl trimethyl ammonium chloride + halo biphenyl sulfur (1 % aqueous solution)	Hyvar XL[a] (Dupont)	n.s.[b]	Lichens and mosses	Stone	Brush application	Very effective	Sadirin [1988]
Sodium dimethyldithio-carbamate + sodium 2-mercaptobenzothiazole	Vancide 51 (R. T. Vanderbilt)	LD_{50r} = 3120 mg/kg	Algae and lichens	Marble, travertine, tuff, and basalt	Spray or poultice applications in various concentrations	Effective for 1–2 years	Giacobini and Bettini [1978]
Streptomycin sulfate	Streptomycin (Sigma)	LD_{50r} = 430 mg/kg	Bacteria	Stone	Brush or spray application	Effective for 7 years	Orial and Brunet 1992
Kanamycin monosulfate	Kanamycin (Sigma)	LD_{50r} = > 4 mg/kg	Bacteria	Stone	Brush or spray application	Effective for 7 years	Orial and Brunet 1992

a has been used in the past in tropical regions

b n.s. = not specified

Table 4.2 Cleaning agents used to clean the growth of microorganisms on building materials

Cleaning agents	Trade name (Manufacturer)	Toxicity data	Organisms targeted	Surface	Method of application	Effectiveness of treatment	References
Ammonium hydroxide[a] (3–10 % in water)	Ammonia[a]	$LD_{50r} = 350$ mg/kg	Fungi, algae, lichens, and mosses	Stone and brick	Brush application	Safe and very effective	Gairola 1968; Lal 1970; Schaffer 1972; Clarke 1977; Fielden 1982
Sodium hypochlorite[a] (1–5% solution)	Clorox	n.s.[b]	Algae, lichens, and mosses	Stone and concrete	Brush application	Effective with a wide range of biological growth	BRE 1952, 1977; Keen 1976; Wright 1986
Urea (25 g) + glycerol (10 ml) in 500 ml of water + clay (attapulgite and sepiolite)	Hempel biological pack	n.s.[b]	Bacteria, fungi, algae, and lichens	Limestone	Clay poultice application	Very effective in breakdown of sulfate crust formed due to the activity of microorganisms	Ashurst 1994
Sodium bicarbonate + ammonium bicarbonate + ethylenediaminetetraacetic acid (EDTA) + carboxymethyl cellulose + Di α (p-tolyl)-dodecyl-trimethylammonium methoxy sulfate (Desogen)	AC 322 (Also known as AB 57 in the US and Europe)	n.s.[b]	Fungi, algae, lichens, and mosses	Stone	Poultice application	Very effective	Siswowiyanto 1981; Caneva, Nugari, and Salvadori 1991; Ashurst 1994; Ashurst and Ashurst 1988

[a] has been used in the past in tropical regions
[b] n.s. = not specified

Table 4.3 Chemicals used as water repellents and consolidants to inhibit the growth of microorganisms on building materials

Chemicals used as water repellents and consolidants	Organisms targeted	Surface	Method of application	Effectiveness of treatment	References
Polymethyl methacrylate[a] (1–3% solution in toluene)	Fungi, algae, lichens, and mosses	Stone	Brush application after treatment with zinc fluosilicate	Effective inhibition for 5 years	Sharma, Kumar, and Sarkar 1989; Shah and Shah 1992–93; Kumar and Sharma 1992
Polyvinyl acetate[a] 1992–93 (1–5% solution in toluene)	Algae, lichens, and mosses	Stone	Brush application after treatment with zinc fluosilicate	Effective inhibition for 3–5 years	Gairola 1968; Shah and Shah
Siliconates	Fungi, algae, lichens, and mosses	Stone	Brush application	Effective	Dukes 1972
Silicone resin water repellent (5%) + 2% o-phenyl phenol in organic solvent	Algae, lichens, and mosses	Concrete	Brush application	Effective	Keen 1976
Silicone resin water repellent[a]	Fungi, algae, lichens, and mosses	Stone and brick	Brush or spray application after toxic wash	Effective	Richardson 1973a, 1973b, 1976

[a] has been used in the past in tropical regions

Chapter 5

Current Research Status and Areas for Further Investigation

Current Research Status

The importance and significance of the biodeterioration of stone in tropical environments is not disputed. There are innumerable papers published on biodeterioration and control methods. Most are descriptive, and only some emphasize the importance of field research and the need for long-term evaluation of remedial measures. Few identify promising avenues for further research.

State of biodeterioration research

Our understanding of the interaction between microorganisms and stone materials has advanced greatly in the last thirty years, mainly because of dramatic improvements in scientific methodologies and awareness of a need for systematic research strategies by multidisciplinary groups. Most of the techniques for identifying microorganisms are well established. Whenever resources have been available, biodeteriogens have been extensively identified prior to the application of biocides.

Biodeterioration is a complex phenomenon, occurring in conjunction with other causes of decay. The phenomenology of this decay is also similar to other physical and chemical causes. It has therefore not been possible to evaluate and isolate the extent of decay caused by biological agencies, particularly microorganisms. There is still much debate about the contribution that microorganisms make to the observed damage to stone materials. Nevertheless, it is possible today to suggest strongly, sometimes even quantitatively, that microorganisms cause stone deterioration and that the deterioration process in the presence of microorganisms is more rapid than exclusively physical and chemical deterioration of stone.

In tropical regions, the understanding of biodeterioration mechanisms is based on primary research conducted elsewhere. However, an increasing effort is being made to fully understand the state of biodeterioration in these areas.

Much research has been centered on lichens, algae, fungi, and bacteria. Mosses and liverworts have drawn comparatively less attention, and their impact has been considered primarily aesthetic. On the other hand, higher plants, when present, have been assumed to be a major cause of destruction of monuments.

Although microbial activity is not always correlated with the number of microorganisms on stone, traditional counts of microbial populations have often been found in the literature. For all microorganisms, the quantitative aspect has been the primary basis for evaluating their importance in the stone deterioration processes. The level of the "normal environmental biological populations" above which these microorganisms could become pathogenic for stone monuments is yet to be established in the field. For instance, intact stone exhibits only a minimal presence of bacteria. A large number of bacteria have, however, frequently been detected along all surfaces of weathered stone structures, especially within cracks and crevices. It is, however, difficult to evaluate whether such observations indicate that bacteria are primarily responsible for stone decay or if weathered surfaces merely provide a more suitable habitat for bacterial growth.

Literature review indicates that although actinomycetes have frequently been identified along with nitrifying bacteria, fungi, and algae, the action of actinomycetes on stone surfaces has not yet been fully understood.

There is a general consensus that cyanobacteria cause significant aesthetic deterioration. The literature also provides considerable evidence that points to the direct physical and chemical damage caused by these organisms. The direct role that cyanobacteria play in supporting the growth of heterotrophic organisms has also been acknowledged.

The activity of fungi in causing stone deterioration has largely been attributed to the production of corrosive metabolites that can solubilize minerals in a manner similar to other chemical processes. The role of acids produced by fungi isolated from the stone monuments has been well demonstrated in the laboratory; however, results from laboratory experiments cannot always be directly correlated with metabolic activities of fungi on the stone surface in the field.

The aesthetic and chemical deterioration caused by algae has been well recognized. Algae are known to produce a variety of acids that may cause stone deterioration. There is also some evidence that endolithic algae have the ability to penetrate into the stone and widen the preexisting cavities and fissures. More significant is the fact that algae support the growth of more corrosive biodeteriogens such as lichens, mosses, liverworts, and higher plants.

The contribution of lichens in stone degradation has been well documented. They are known to cause chemical damage through the production of biogenic acids and physical damage through the penetration of their rhizoid/hyphae into the fissures in the stone. The role of chelating agents, such as polyphenolic compounds, in stone deterioration has been established but is less well studied than the role of oxalic acids. It has been found that oxalate crusts may be the direct result of oxalic acids released by lichen and fungi; however, it is not always clear whether the crusts are protective or detrimental to stone.

The most widely recognized form of deterioration by the mosses and liverworts is aesthetic; however, it has also been acknowledged that they may cause some degree of biochemical disintegration.

The mechanism of physical damage that may occur due to the penetration of their rhizoids into stone has not been well established. These organisms have also been found to support the growth of more destructive higher plants.

Biodeterioration caused by higher plants has been extensively discussed in the literature, particularly in relation to tropical environments. Although biophysical deterioration has been acknowledged to be the most destructive in these regions, the chemical role of plant roots in the mechanism of stone deterioration has also received some attention.

Not many studies exist on interactions among different groups of organisms in a single ecosystem, for example, bacteria-algae, fungi-algae, mosses-algae, in tropical regions. There is also not much information available on the susceptibility of a wide range of stone types to microbial deterioration. The role of microbial biofilms in deterioration and discoloration of various stone types is also not fully understood. These are important areas for investigation, since organisms can act in a synergistic manner in deterioration of stone. In instances where several types of microorganisms are present, it is difficult to assess whether or not each one is detrimental to the stone. Although this has not received particular attention, it is important when selective biocides are used. This study may be helpful in selecting suitable biocides.

To date, potentially dangerous activities of biodeteriogens have generally been demonstrated in the laboratories, a situation that sometimes results in misleading conclusions regarding the situation in the field. However, some basic qualitative information on biodeteriogens on the stone surface and their deterioration mechanisms has been obtained by examining field samples with various analytical tools such as scanning electron and fluorescent microscopy.

Preventive and remedial methods

There are several accounts of biocidal treatments worldwide. However, there is insufficient published information on their relative effectiveness over an extended period of time in the field. Periodic qualitative and quantitative monitoring has not been generally considered vital in the assessment of the efficacy of biocides on the substrata. In practice, visual observation of the appearance of microorganisms on monuments has been the sole method for evaluating the long-term effectiveness of biocides in tropical regions.

Generally, the selection of biocides for use on stone monuments in tropical regions has been based on their apparent successful use elsewhere on different materials, their availability, and their affordability. Most of the evaluation tests have been based on empirical tests in the field. Literature review indicates that no biocides are uniformly effective on all organisms, in all environments, and on all stone surfaces. More work needs to be done specifically on testing of biocides on different stone surfaces, particularly within the framework of other conservation treatments in order to avoid interactions with conservation materials that may be used later.

Not much attention has been given to selection of new biocides based on their molecular structure and activity relationship properties. Testing has relied heavily on information provided by the manufacturers. There is a great need to study thoroughly the chemistry of substances that are being considered for use as biocides. The availability of this type of information may help eliminate the selection of inappropriate or ineffective biocides.

This literature survey indicates that most of the existing research on biocides has been concerned with eliminating algae, lichens, fungi, mosses, liverworts, and higher plants. Despite the extensive work on the role of bacteria in stone decay, relatively little research has been conducted on antibacterial treatments for stone. More research into possible antibacterial treatment is necessary.

Copper compounds are well known for their toxic effects on biodeteriogens and their low environmental impacts. Although these compounds have residual effects that could enhance their long-term efficacy on stone, their use has been restricted due to the possibility of staining. Use of copper compounds has seldom been reported in tropical regions. On the other hand, the successful use of low concentrations of zinc hexafluosilicate (~1–2%), a residual biocide, has been extensively documented in the field in tropical regions. However, the use of higher concentrations of this compound in some cases has been reported to produce hard surface skins on limestones.

Research is required to identify such residual biocidal systems within the established criteria of biocides selection for combating the biodeterioration of stone monuments. In areas of heavy rainfall, the development of effective residual biocides, such as copper- or zinc-based compounds, could be very useful in prolonging the time between reapplications. Consideration must, however, be given to the potential environmental and public health hazards due to prolonged exposure to the substance.

Use of preservative coatings such as water repellents has been recommended, particularly in tropical regions, following a biocidal treatment in order to keep the stone surfaces dry and thereby inhibit biological growth. The ability of these substances to enhance the longevity of biocidal activity has also been considered. The evaluation of their effectiveness, however, has usually been based on their physical and chemical stability and their physical and chemical interactions with the stone surface. Rarely has their interaction with potential microbes on the stone surface received consideration.

The importance of the interaction of these preservative coatings with microorganisms on the stone surface has only recently been acknowledged. Several research groups and microbiological laboratories have recently focused their attention on the interaction of stone conservation treatments with microorganisms inhabiting stones. Thus far, the results of their studies indicate that many of the materials traditionally used in conservation have the ability to support microbial growth. Field experience, however, suggests that when appropriately applied on clean stone surfaces, these treatments are usually effective in inhibiting biologi-

cal growth. In tropical areas, periodic cleaning has been found not only necessary but also critical in controlling the initial establishment of biodeteriogens and their subsequent growth.

Few efforts have been made to investigate traditional techniques that used natural products as biocides. In tropical environments this may prove to be a more viable and cost-effective solution than the use of some chemicals and synthetic products. Although these natural products may not be hazardous to the environment, their potential toxicity to humans must not be ignored.

Evaluation of biocides

Most researchers have been successful in devising their own laboratory procedures for evaluating treatments. However, they have not been as successful in the field. Evaluation procedures for biocides can be designed to demonstrate short-term effectiveness or may be concerned with monitoring long-term performance. Standard criteria to assess the extent to which the treatment has been successful do not exist. Such criteria and methods for evaluation of biocides, both in the field and in the laboratory, are essential if meaningful comparisons of the results of different laboratories are to be made.

In light of the foregoing, any decision concerning biocide application must not be undertaken hastily or without careful consideration of the wider implications and long-term effects. The problem seems to be underresearched, and much of the work published to date has yet to be adequately substantiated by long-term experimentation.

Areas for Further Investigation

Biodeterioration research demands an interdisciplinary approach, and the outcome of the study must have application in the field. This does not imply that long-term strategic and fundamental research should be discouraged, but that such work must ultimately contribute to the care and preservation of cultural heritage. The following areas need to be considered for further study.

- More precise methods for identifying biodeteriogens
- Quantitative and qualitative assessment of the damage caused by individual biodeteriogens
- Interrelationships of various biodeteriogens
- Microbial interactions with various types of stone
- Ecology of biodeteriogens
- Possibility of other conservation treatments supporting microbial growth
- Traditional methods for control of biodeteriogens on stone monuments
- Criteria for selection of biocides
- Methods of in situ evaluation of biocides
- Relative long-term and short-term effectiveness of biocides

- Interaction of biocides with various stone surfaces
- Interaction of biocides with other conservation materials applied to the stone surface before or after biocide application
- Development of effective residual biocides
- Development of biocidal consolidant
- Antibacterial treatments
- Possibility of inoculating a microorganism that kills and prevents the invasion of damage-causing microorganisms but does not itself attack stone surfaces

The above tasks are interdisciplinary and will require collaboration among specialists from various organizations and institutions that are not necessarily involved in the conservation of cultural heritage.

Glossary

abiotic Nonliving; of nonbiological origin.

angiosperms Flowering plants; the group (often classified as a class or division) Anthophyta or Magnoliophyta, containing seed plants in which the ovules are enclosed within carpels.

autotroph An organism that uses carbon dioxide for its carbon requirement; often used to imply lithoautotrophy, as obligate autotrophs appear to be either chemolithotrophs or photolithotrophs.

bacillariophytes A large group of algae that are essentially unicellular (some colonial, some forming filaments) and that have a characteristic type of cell wall, consisting typically of a siliceous structure encased in an organic layer.

biodeteriogen An organism or microorganism that causes undesirable changes in the constituent materials of (esp. cultural) objects.

biofilm A film of microorganisms, usually embedded in extracellular polymers, that adheres to surfaces submerged in, or subjected to, aquatic environments.

chelate A chemical agent that combines with metal ions.

chelation A chemical process involving the formation of heterocyclic ring compounds containing at least one metal cation or hydrogen ion.

chemoautotroph An organism whose energy is derived from endogenous, light-independent chemical reactions (a mode of metabolism termed **chemotrophy**); a chemotroph that obtains energy by the oxidation of inorganic substrate(s) (i.e., a lithotroph, called **chemolithotroph**); one that obtains energy by metabolizing organic substrate(s) (i.e., an organotroph, called a **chemoorganotroph**).

chlorophytes A group of algae characterized by a combination of features (e.g., containing chlorophylls a and b, ß-carotene, and xanthophylls such as antheraxanthin, lutein, neoxanthin, violaxanthin, and zeaxanthin).

chloroplasts Organisms evolved by a double membrane; the main storage polymer is starch, which is formed within the chloroplast. Motile cells, when formed, bear flagella.

crustose Forming or resembling a crust; especially of lichens, having a thallus that generally lacks a lower cortex, being attached to the substratum (over the whole of its lower surface) by hyphae of the medulla.

efflorescence Growth of salt crystals or powdery deposits on surfaces due to evaporation of salt-laden water.

endolithic Growing within rocks, as some algae, lichens, and bacteria do in limestone.

epilithic Growing on a rock surface.

eukaryotes A group of organisms; literally those having "nuclei" in their cells (i.e., animals, plants, and fungi) in contrast to the prokaryotic cells of bacteria and blue-green algae; possessing a nucleus bounded by a membranous nuclear envelope and having many cytoplasmic organelles.

foliose Leafy, having a body differentiated into stem and leaves; of a lichen: having a flattened leaflike thallus more or less firmly attached to the substratum.

fruticose Shrublike; of a lichen: having a thallus that is threadlike (terete) or straplike (more or less flattened), and either erect and shrubby or pendulous, the thallus being attached to the substratum by a holdfast or unattached.

gymnosperms A group (classified as a division Gymnospermophyta or a class Gymnospermae, or regarded as polyphyletic) containing those seed plants in which the ovules are not enclosed in carpels, the pollen typically germinating on the surface of the ovule.

heterotroph An organism that uses organic compounds for most or all of its carbon requirements; often used to refer specifically to chemoorganoheterotrophs, although chemolithotrophs and phototrophs may also be heterotrophic.

hyphae Branched or unbranched filaments, many of which together constitute the vegetative form of the organism and (in some species) form the sterile portion of a fruiting body. *See also* mycelium.

meristematic Rapidly dividing cells at the tip of the stem, root, or branch.

metabolite Any of various compounds produced by metabolism.

mycelium A mass of branching hyphae; the vegetative body (thallus) of most true fungi.

photoautotroph An autotroph that requires sunlight to provide necessary energy for biosynthesis.

photoheterotroph A heterotroph that requires sunlight to provide necessary energy for biosynthesis.

photolithotroph An organism that uses inorganic substrates (e.g., water, sulfur, sulfide, H_2, or thiosulphate) as an electron donor in photosynthesis.

photoorganotroph An organism that uses an organic substrate as an electron donor in phototrophic metabolism.

prokaryote A type of microorganism in which the chromosomes are not separated from the cytoplasm by a specialized membrane that is typically devoid of sterols and in which mitochondria and chloroplasts are absent.

pteridophyte Any plant of the division Pteridophyta (including the ferns, club mosses, and horsetails), which does not bear seeds.

redox reaction A chemical reaction in which electrons are transferred between atoms, ions, or molecules.

rhizoid A rootlike structure consisting of a compact bundle of hyphae; arising mainly from the lower surface of the (usually foliose) thallus and serving to anchor the thallus to the substratum; in some species, may also facilitate the uptake of water and nutrients by thallus.

spermatophyte Any plant of the division Spermatophyta, which includes all seed-bearing plants.

taxonomy The science of classification as applied to living organisms, including the study of the means of species formation.

thallus Plant body not differentiated into leaves, stems, and roots, but consisting of a mycelium or a colony, a filament of cells, a mycelium, or a large branching multicellular structure; the plant body of the algae, fungi, and liverworts.

vascular Relating to vessels that convey fluids or provide for the circulation of fluids (e.g., xylem and phloem); provided with vessels for the circulation of fluids.

xerophilous Flourishing in or able to withstand a dry, hot environment.

References

Agrawal, O. P., T. Singh, B. V. Kharbade, K. K. Jain, and J. P. Joshi
1987. Discoloration of Taj Mahal marble: A case study. In *ICOM Committee for Conservation Preprints, 8th Triennial Meeting, Sydney, Australia, 6–11 September, 1987*, 447–51. Marina del Rey: Getty Conservation Institute.

Agarossi, G., R. Ferrari, M. Monte, C. Gugliandolo, and M. Maugeri
[1988]. Changes of microbial system in an Etruscan tomb after biocidal treatments. In *6th International Congress on Deterioration and Conservation of Stone*, vol. 2, comp. J. Ciabach, 82–91. Torun, Poland: Nicholas Copernicus University Press Department.

Akin, W. E.
1991. *Global Patterns: Climate, Vegetation and Soils*. Norman: University of Oklahoma Press.

Allsopp, C., and D. Allsopp
1983. An updated survey of commercial products used to protect materials against biodeterioration. *International Biodeterioration Bulletin* 19(3/4):99–145.

Allsopp, D., and K. J. Seal
1986. *Introduction to Biodeterioration*. London: Edward Arnold.

Alstrup, V., and E. S. Hansen
1977. Three species of lichens tolerant of high concentrations of copper. *Okios* 29:290–93.

Anagnostidis, K., A. Economou-Amilli, and M. Roussomoustakaki
1983. Epilithic and chasmolithic microflora (Cyanophyta, Bacillariophyta) from marbles of the Parthenon (Acropolis-Athens, Greece). *Nova Hedwigia* 38:227–87.

Andreoli, C., N. Rascio, L. Garlet, S. Leznicka, and A. Strzelczyk
[1988]. Interrelationships between algae and fungi overgrowing stoneworks in natural habitats. In *6th International Congress on Deterioration and Conservation of Stone*, vol. 2, comp. J. Ciabach, 324–27. Torun, Poland: Nicholas Copernicus University Press Department.

Arai, H.
1985. Biodeterioration of stone monuments and its counter measure. In *Conservation and Restoration of Stone Monuments*, 84–95. Tokyo: Tokyo National Research Institute of Cultural Properties.

Aranyanak, C.
1992. Biodeterioration of cultural materials in Thailand. In *Proceedings of the 2nd International Conference on Biodeterioration of Cultural Property, October 5–8, 1992, Held at Pacifico Yokohama*, ed. K. Toishi, H. Arai, T. Kenjo, and K. Yamano, 23–33. Tokyo: International Communications Specialists.

Ascaso, C., J. Galvan, and C. Ortega-Calvo
1976. The pedogenic action of *Parmelia conspersa, Rhizocarpon geographicum* and *Umbilicaria pustulata*. *Lichenologist* 8:151–71.

Ascaso, C., J. Galvan, and C. Rodriguez-Pascual
1982. The weathering of calcareous rocks by lichens. *Pedobiologia* 24:219–29.

Ashurst, J.
1975. Stone: Cleaning surface treatments. *Architects' Journal* 2(27):39–49.

Ashurst, J., and N. Ashurst
1988. *Stone Masonry*. Vol. 1 of *Practical Building Conservation*. Aldershot, England: Gower Technical Press.

Ashurst, N.
1994. *Cleaning Historic Buildings*. 2 vols. London: Donhead.

Bassi, M., and C. Giacobini
1973. Scanning electron microscopy: A new technique in the study of the microbiology of works of art. *International Biodeterioration Bulletin* 9:57–68.

Bassi, M., N. Barbieri, and R. Bonecchi
1984. St. Christopher's church in Milan: Biological investigations. *Arte Lombarda* 68/69:117–21.

Bech-Anderson, J.
1986. Biodeterioration of natural and artificial stone caused by algae lichens mosses and higher plants. In *Biodeterioration 6: Papers Presented at the 6th International Biodeterioration Symposium, Washington, D.C., August 1984*, ed. Sheila Barry and D. R. Houghton, 126–30. Slough, England: CAB International Mycological Institute and The Biodeterioration Society.

1987. Oxalic acid production by lichens causing deterioration of natural and artificial stones. In Biodeterioration of Constructional Materials: Proceedings of the Summer Meeting of the *Biodeterioration Society Held at TNO Division of Technology for Society, Delft, the Netherlands, 18–19 September, 1986*, ed. L. H. G. Morton, 9–13. Kew, England: Biodeterioration Society.

Bech-Anderson, J., and P. Christensen
1983. Studies of lichen growth and deterioration of rocks and building materials using optical methods. In *Biodeterioration 5: Papers Presented at the 5th International Biodeterioration Symposium, Aberdeen, September 1981*, ed. Sheila Barry, 568–72. Chichester, England: John Wiley and Sons.

Becker, T. W., W. E. Krumbein, T. Warscheid, and M. A. Resende
1994. Investigations into microbiology. In IDEAS—Investigations into Devices Against Environmental Attack on Stones: A German-Brazilian Project, 147–85. Geesthacht, Germany: GKSS-Forschungszentrum Geesthacht Gmbh.

Bell, D.
1984. The role of algae in the weathering of Hawkesbury sandstone: Some implications for rock art conservation in the Sydney area. *Institute for the Conservation of Cultural Material Bulletin*, Canberra 10:5–12.

Bell, W. H., J. M. Lang, and R. Mitchell
1974. Selective stimulation of marine bacteria by algal extra cellular products. *Limnology and Oceanography* 19:833–39.

Benassi, R., S. B. Curri, R. D. Harvey, and A. Paleni
1976a. Organic matter in some carbonate rocks used as building stone and in monumental works as revealed by TLC and petrographic analyses. In *Proceedings of Section Lipids and Works of Art of the 13th World Congress of the International Society for Fat Research, Marseille (France), August 31, 1976*, 55–63. Modena, Italy: Poligrafico Artioli.

Benassi, R., S. B. Curri, K. Serk-Hanssen, and A. Paleni
1976b. TLC, GC, MS analysis of extracts by chloroform and methyl alcohol (3:1) from the flora pushing on marble columns of Santa Fosca Arcade, Torcello, Venice. In *Proceedings of Section Lipids and Works of Art of the 13th World Congress of the International Society for Fat Research, Marseille (France), August 31, 1976*, 65–73. Modena, Italy: Poligrafico Artioli.

Bettini, C., and A. Villa
1981. A description of a method for cleaning tombstones. In *Conservation of Stone 2: Preprints of the Contributions to the International Symposium, Bologna, 27–30 October 1981*, ed. Raffaella Rossi-Manaresi, 523–34. Bologna: Centro per la conservazione delle sculture all'aperto.

Bitton, G., and B. Koopman
1982. Tetrazolium reduction-malachite green method for assessing the viability of filamentous bacteria in activated sludge. *Applied and Environmental Microbiology* 43:964–66.

Bold, H. C., and M. J. Wynne
1985. *Introduction to the Algae*. 2d ed. Upper Saddle River, N.J.: Prentice Hall.

Bradley, S. M.
1985. Evaluation of organo-silanes for use in consolidation of sculpture displayed outdoors. In *5th International Congress on Deterioration and Conservation of Stone, Proceedings, Lausanne, 25–27 September 1985*, vol. 2, comp. G. Félix, 759–68. Lausanne, Switzerland: Presses polytechniques romandes.

Brightman, F. H., and M. R. D. Seaward
1977. Lichens of man-made substrates. In *Lichen Ecology*, 253–93. London: Academic Press.

Brown, S. K., and A. N. Souprounovich
1989. Cleaning and painting of weathered asbestos cement roofing. *Surface Coatings Australia* 26(5):6–9.

Building Research Establishment (BRE)
1975. Decay and conservation of stone masonry. *BRE Digest* 177.

1982. Control of lichens, moulds and similar growths. *BRE Digest* (139):1–4.

Campbell, S. E.
1979. Soil stabilization by a prokaryotic desert crust: Implications for Precambrian land biota. *Origins of Life* 9:335–48.

Caneva, G., and A. Altieri
[1988]. Biochemical mechanisms of stone weathering induced by plant growth. In *6th International Congress on Deterioration and Conservation of Stone*, vol. 1, comp. J. Ciabach, 32–44. Torun, Poland: Nicholas Copernicus University Press Department.

Caneva, G., A. Danin, S. Ricci, and C. Conti
1994. The pitting of Trajan's column, Rome: An ecological model of its origin. *Conservazione del patrimonio culturale*, 78–102. Contributi del Centro linceo interdisciplinare "Beniamino Segre," no. 88. Rome: Accademia Nazionale dei Lincei.

Caneva, G., M. P. Nugari, and O. Salvadori
1991. *Biology in the Conservation of Works of Art*. Rome: ICCROM.

Caneva, G., and A. Roccardi
1991. Harmful flora in the conservation of Roman monuments. In *Biodeterioration of Cultural Property: Proceedings of the International Conference on Biodeterioration of Cultural Property, February 20–25, 1989, Held at National Research Laboratory for Conservation of Cultural Property, in Collaboration with ICCROM and INTACH*, ed. O. P. Agrawal and Shashi Dhawan, 212–18. New Delhi: Macmillan India.

Caneva, G., and O. Salvadori
1988. Biodeterioration of stone. In *Deterioration and Conservation of Stone*, ed. Lorenzo Lazzarini and Richard Pieper, 182–234. Studies and Documents on the Cultural Heritage, no. 16. Paris: Unesco.

Casarett, L. J., M. O. Amdur, and C. D. Klaassen
1995. *Casarett and Doull's Toxicology: The Basic Science of Poisons*. 5th ed. New York: McGraw-Hill.

Cepero, A.
1990. Algunas cuestiones relacionadas con el medio ambiente: La corrosión y el deterioro de los bienes culturales. *Documentos (Grupo de Información Esfera de las Artes Visuales)* (2/3):70–83.

Cepero, A., P. Martinez, J. Castro, A. Sanchez, and J. Machado
1992. The biodeterioration of cultural property in the republic of Cuba: A review of some experiences. In *Proceedings of the 2nd International Conference on Biodeterioration of Cultural Property, October 5–8, 1992, Held at Pacifico Yokohama,* ed. K. Toishi, H. Arai, T. Kenjo, and K. Yamano, 479–87. Tokyo: International Communications Specialists.

Charola, A. E., L. Lazzarini, G. E. Wheeler, and R. J. Koestler
1986. The Spanish apse from San Martín de Fuentidueña at the Cloisters, Metropolitan Museum of Art, New York. In *Case Studies in the Conservation of Stone and Wall Paintings: Preprints of the Contributions to the Bologna Congress, 21–26 September 1986,* ed. N. S. Brommelle and Perry Smith, 18–21. London: International Institute for Conservation of Historic and Artistic Works.

Ciarallo, A., L. Festa, C. Piccioli, and M. Raniello
1985. Microflora action in the decay of stone monuments. In *5th International Congress on Deterioration and Conservation of Stone, Proceedings, Lausanne, 25–27 September 1985,* vol. 2, comp. G. Félix, 607–16. Lausanne, Switzerland: Presses polytechniques romandes.

Clarke, J.
1976. A lichen control experiment at an aboriginal rock engraving site, Bolgart, Western Australia. *Institute for the Conservation of Cultural Material Bulletin, Canberra* 2:15–17.

1978. Conservation and restoration of painting and engraving sites in Western Australia. In *Conservation of Rock Art: Proceedings of the International Workshop on the Conservation of Rock Art, Perth, September 1977,* ed. C. Pearson, 89–94. Sydney: Institute for the Conservation of Cultural Material.

Curri, S. B., and A. Paleni
1976. Some aspects of the growth of chemolithotrophic micro-organisms on the Karnak Temples. In *Conservation of Stone 1: Proceedings of the International Symposium, Bologna, June 19–21, 1975,* ed. R. Rossi-Manaresi, 267–79. Bologna: Centro per la conservazione delle sculture all'aperto.

1981. Histochemical procedures for the evaluation of organic components in deteriorated stone materials. In *Conservation of Stone 2: Preprints of the Contributions to the International Symposium, Bologna, 27–30 October 1981,* ed. Raffaella Rossi-Manaresi, 445–54. Bologna: Centro per la conservazione delle sculture all'aperto.

Danin, A.
1983. Weathering of limestone in Jerusalem by cyanobacteria. *Zeitschrift fur Geomorphologie,* Neue Folge 27:413–21.

1986. Patterns of biogenic weathering as indicators of paleoclimates in Israel. *Proceedings of Royal Society of Edinburgh* 89B:243–53.

Danin, A., and G. Caneva
1990. Deterioration of limestone walls in Jerusalem and marble monuments in Rome caused by cyanobacteria and cyanophilous lichens. *International Biodeterioration* 26(6):397–417.

Dawson, J.
1982. Some considerations in choosing a biocide. *Proceedings of the ICOM Waterlogged Wood Working Group Conference, Ottawa 1981,* ed. D. W. Grattan, 269–77. Ottawa: International Council of Museums, Committee for Conservation, Waterlogged Wood Working Group.

Del Monte, M.
1991. Trajan's column: Lichens don't live here anymore. *Endeavour* 15:86–93.

de la Torre, M. A., G. Gomez-Alarcon, and J. M. Palacios
1993. In vitro biofilm formation by *Penicillium frequentans* strains on sandstone, granite, and limestone. *Appl. Microbiol. Biotechnol.* 40:408–15.

de la Torre, M. A., G. Gonzalo, C. Vizcaino, and M. T. Garcia
1993. Biochemical mechanisms of stone alteration carried out by filamentous fungi living in monuments. *Biogeochemistry* 19:129–47.

Delvert, J.
1963. Recherches sur l' "erosion" des gres des monuments d'Angkor. *Bulletin de l'Ecole Française d'Extrême Orient* 51(1/2):453–534.

De Marco, G., G. Caneva, and A. Dinelli
1990. Geobotanical foundation for a protection project in the Moenjodaro archaeological area. *Prospezione Archeologiche* 1:115–20.

Denyer, S. P.
1990. Mechanisms of actions of biocides. *International Biodeterioration* 26:397–417.

De Winder, B., J. Pluis, L. De Reus, and L. R. Mur
1989. Characterization of a cyanobacterial, algal crust in the coastal dunes of the Netherlands. In *Microbial Mats: Physiological Ecology of Benthic Microbial Communities*, ed. Y. Cohen and E. Rosenberg, 77–83. Washington, D.C.: American Society for Microbiology.

Diakumaku, E.
1996. Investigations on the role of black fungi and their pigments in the deterioration of monuments. Ph.D. diss., University of Oldenburg, Germany.

Division of Building Research, CSIRO
1977. Ridding roofs of lichen growth. Division of Building Research Information Service, Commonwealth Scientific and Industrial Research Organization, Highett, Australia, Sheet no. 10-19. Pamphlet.

Duff, R. B., D. M. Webley, and R. O. Scott
1963. Solubilization of minerals and related minerals by 2-ketogluconic acid producing bacteria. *Journal of Soil Science* 95:105–14.

Dukes, W. H.
1972. Conservation of stone: Causes of decay. *Archaeological Journal* 156:429–32.

Eckhardt, F. E. W.
1985. Mechanisms of the microbial degradation of minerals in sandstone monuments, medieval frescoes and plaster. In *5th International Congress on Deterioration and Conservation of Stone, Proceedings, Lausanne, 25–27 September 1985*, vol. 2, comp. G. Félix, 643–52. Lausanne, Switzerland: Presses polytechniques romandes.

Eckhardt, F. E. W.
[1988]. Influence of culture media employed in studying microbial weathering of building stones and monuments by heterotrophic bacteria and fungi. In *6th International Congress on Deterioration and Conservation of Stone*, vol. 2, comp. J. Ciabach, 71–81. Torun, Poland: Nicholas Copernicus University Press Department.

Ehrlich, H. L.
1981. *Geomicrobiology*. New York: Marcel Deckker.

Fielden, B. M.
1982. *Conservation of Historic Buildings*. London: Butterworth Scientific.

Fliermans, C. B., and E. L. Schmidt
1977. Luminofluorescence for autoecological study of a unicellular blue-green algae. *Journal of Phycology* 13:364–68.

Florian, M. L. E.
1978. A review: The lichen role in rock art-dating, deterioration and control. In Conservation of Rock Art: Proceedings of the International Workshop on the Conservation of Rock Art, Perth, September 1977, ed. C. Pearson, 95–98. Canberra, Australia: Institute for the Conservation of Cultural Material.

Fogg, G. E., W. D. P. Stewart, P. Fay, and A. E. Walsby
1973. *The Blue-Green Algae.* London: Academic Press.

Fosberg, F. R.
1980. *The Plant Ecosystem for Moenjodaro.* Unesco Technical Report no. RP/1977-78/4.121.6, FMR/CC/CH/80/189. Paris: Unesco.

Frey, T., J. von-Reis, and Z. Barov
1993. An evaluation of biocides for control of the biodeterioration of artifacts at Hearst Castle. In *ICOM Committee for Conservation, 10th Triennial Meeting, Washington, D.C., USA, 22–27 August, 1993, Preprints,* vol. 2, ed. J. Bridgland, 875–81. Paris: ICOM Committee for Conservation.

Friedmann, E. I.
1971. Light and scanning electron microscopy of the endolithic desert algal habitat. *Phycologia* 10:411–28.

Fry, M. F.
1985. The problems of ornamental stonework—lichen. *Stone Industries* 20(2):22–25.

Fusey, P., and G. Hyvert
1964. Les altérations physicochimiques et biologiques des grès des monuments Khmers. *Comptes Rendus des Séances de l'Académie des Sciences* 258:6573–75.

1966. Biological deterioration of stone monuments in Cambodia. *Monograph of the Society for Chemical Industry* 23:125–29.

Gairola, T. R.
1968. Examples of the preservation of monuments in India. In *The Conservation of Cultural Property, with Special Reference to Tropical Conditions,* 139–52. Paris: Unesco.

Galizzi, A., E. U. Ferrari, and L. Ginetti
1976. Identification of *Thiobacilli* by replica plating. In *Conservation of Stone 1: Proceedings of the International Symposium, Bologna, June 19–21, 1975,* ed. R. Rossi-Manaresi, 221–23. Bologna: Centro per la conservazione delle sculture all'aperto.

Gangstad, E. O.
1982. *Weed Control Methods for Rights-of-Way Management.* Boca Raton, Fla.: CRC Press.

Garcia-Rowe, J., and C. Saiz-Jimenez
1991. Lichens and bryophytes as agents of deterioration of building materials in Spanish cathedrals. *International Biodeterioration* 28:151–63.

Garg, K. L., S. Dhawan, and O. P. Agrawal
1988. *Deterioration of Stone and Building Materials by Algae and Lichens: A Review.* Lucknow, India: National Research Laboratory for Conservation of Cultural Property.

Garg, K. L., A. K. Mishra, A. Singh, and K. K. Jain
1995. Biodeterioration of cultural heritage: Some case studies. In *Conservation, Preservation and Restoration: Traditions, Trends and Techniques,* ed. G. Kamlakar and V. Pandit Rao, 31–38. Hyderabad, India: Birla Archaeological and Cultural Research Institute.

Garnier, B. J.
1958. *Some Comments on Defining the Humid Tropics.* Research Notes, no. 11. [Ibadan, Nigeria: University of Ibadan, Department of Geography.]

Gaustein, W. C., K. Cromack, and P. Sollins
1977. Calcium oxalate: Occurrence in soils on nutrient and geochemical cycles. *Science* 198:1252–54.

Gavin, J. J., and D. P. Cummings
1972. Enumeration of microorganisms. In *Handbook of Microbiology,* vol. 1, 661–70. Cleveland: CRC Press.

Gayathri, P.
1982. On release of trace elements from lichens. *Birla Archaeological and Cultural Research Institute, Research Bulletin* 4:23–28.

Giacobini, C., and C. Bettini
[1978]. Traitement des vestiges archéologiques détériorés par les lichens et les algues. In *Altération et protection des monuments en pierre, colloque international, Paris, du 5 au 9 juin 1978/Deterioration and Protection of Stone Monuments, International Symposium, Paris, June 5–9 1978*, pt. 4.3. Paris: Unesco-RILEM.

Giacobini, C., M. P. Nugari, M. P. Micheli, B. Mazzone, and M. R. D. Seaward
1985. Lichenology and the conservation of ancient monuments: An interdisciplinary study. In *Biodeterioration 6: Papers Presented at the 6th International Biodeterioration Symposium, Washington, D.C., August 1984*, ed. Sheila Barry and D. R. Houghton, 386–92. Slough, England: CAB International Mycological Institute and The Biodeterioration Society.

Giacobini, C., A. Roccardi, M. Bassi, and M. A. Favali
1988. The use of electron microscope in research of biodeterioration of works of art. In *Biodeterioration 7: Selected Papers Presented at the Seventh International Biodeterioration Symposium, Cambridge, U.K., 6–11 September 1987*, ed. D. R. Houghton, R. N. Smith, and H. O. W. Eggins, 418–27. New York: Elsevier Applied Science.

Giantomassi, C., R. Luján, P. Pagnin, and D. Zari
1993. *Mayanmar: Conservation of Mural Paintings, External Stuccoes and Stone Buildings*. Report, Conservation of Cultural Heritage of Selected Sites in Mayanmar, Unesco document no. FMR/CLT/CH/93/208(UNDP). Paris: Unesco.

Gilbert, O. L.
1977. Lichen conservation in Britain. In *Lichen Ecology*, 415–36. London: Academic Press.

Gill, W. R., and G. H. Bolt
1955. Pfeffer's studies of the root growth pressures exerted by plants. *Agronomy Journal* 47:166–68.

Golubic, S.
1973. The relationship between blue-green algae and carbonate deposits. In *The Biology of Blue-Green Algae*, 434–72. Oxford, England: Blackwell.

Golubic, S., G. Brunet, and T. Le Campion
1970. Scanning electron microscopy of endolithic algae and fungi using a multipurpose casting-embedding technique. *Lethaia* 3:203–9.

Golubic, S., E. Friedmann, and J. Scheider
1981. The lithobiotic ecological niche, with special reference to microorganisms. *Journal of Sedimentary Petrology* 51:475–78.

Gourou, P.
1966. *The Tropical World*. 4th ed. London: Longman.

Grant, C., and A. F. Bravery
1981a. Laboratory evaluation of algicidal biocides for use on construction materials, 1: An assessment of some current test methods. *International Biodeterioration Bulletin* 17:113–23.

1981b. Laboratory evaluation of algicidal biocides on construction materials, 2: Use of the vermiculite bed technique to evaluate a quaternary ammonium biocide. *International Biodeterioration Bulletin* 17(4):125–31.

1985a. A new method for assessing the resistance of stone to algal disfigurement and the efficacy of chemical inhibitors. In *5th International Congress on Deterioration and Conservation of Stone, Proceedings, Lausanne, 25–27 September 1985*, vol. 2, comp. G. Félix, 663–74. Lausanne, Switzerland: Presses polytechniques romandes.

1985b. Laboratory evaluation of algicidal biocides on constructional materials, 3: Use of the vermiculite bed technique to evaluate toxic washes. *International Biodeterioration* 21(4):285–93.

Griffin, P. S., N. Indictor, and R. J. Koestler
1991. The biodeterioration of stone, a review of deterioration mechanisms: Conservation case histories and treatment. *International Biodeterioration* 28:187–207.

Gugliandolo, C., and T. L. Maugeri
[1988]. Isolation of *Thiobacillus* spp. from stone. In *6th International Congress on Deterioration and Conservation of Stone*, vol. 2, comp. J. Ciabach, 92–101. Torun, Poland: Nicholas Copernicus University Press Department.

Hale, M. E.
1980. Control of biological growths on Mayan archaeological ruins in Guatemala and Honduras. In *National Geographic Research Reports*, 1975 Projects, 305–21. Washington, D.C.: National Geographic Society.

1983. *The Biology of Lichens*. 3d ed. London: Edward Arnold.

Hallbaur, D. K., and H. M. Jahns
1977. Attack of lichens on quartzite rock surfaces. *Lichenologist* 9:119–22.

Harvey, R. W., and L. Y. Young
1980. Enumeration of particle-bound and unattached respiring bacteria in the salt marsh environment. *Applied and Environmental Microbiology* 40:156–60.

Heck, W. W., and C. S. Brandt
1977. Effects on vegetation. In *Air Pollution*, vol. 2, 157–229. New York: Academic Press.

Hellebust, J. A.
1974. Extracellular products. In *Algal Physiology and Biochemistry*, 157–229. New York: Academic Press.

Henderson , M. E. K., and R. B. Duff
1963. The release of metallic and silicate ions from minerals, rocks and soils by fungal activity. *Journal of Soil Science* 14:236–46.

Honeyborne, D. B.
1990. Weathering and decay of masonry. In *Conservation of Building and Decorative Stone*, vol. 1, ed. John Ashurst and Francis G. Dimes, 153–84. London: Butterworth-Heinemann.

Hueck–van der Plas, E. H.
1965. The biodeterioration of materials as a part of hylobiology. *Material und Organismen* 1(1):5–34.

1968. The microbiological deterioration of porous building materials. *International Biodeterioration Bulletin* 4(1):11–28.

Hyvert, G.
1966. Quelques Actinomycetes isolés sur les gres des monuments cambodgiens. *Revue de mycologie* 31(2):179–86.

1972. *The Conservation of Borobudur Temple*. Unesco document no. RMO. RD/2646/CLP. Paris: Unesco.

1973. Borobudur, les bas-reliefs matériaux-facteurs responsables des dégradations—Programme de conservation. *Studies in Conservation* 18:131–55.

Ionita, I.
1971. Contributions to the study of the biodeterioration of works of art and historic monuments, 3: Species of fungi isolated from stone monuments. *Rev. Roum. Biol. Botanique* 16(6):433–36.

Iskandar, I. K., and J. K. Syers
1972. Metal complex formation by lichen compounds. *Journal of Soil Science* 23:255–65.

Jahns, H. M.
1973. Anatomy, morphology, and development. In *The Lichens*, 3–58. New York: Academic Press.

Jain, K. K., A. K. Mishra, and T. Singh
1993. Biodeterioration of stone: A review of mechanism involved. In *Recent Advances in Biodeterioration and Biodegradation*, vol. 1, ed. K. L. Garg, Neelima Garg, and K. G. Mukerji, 323–54. Calcutta: Naya Prokash.

Jain, K. K., V. K. Saxena, and T. Singh
1991. Studies on the effect of biogenic acids on stone materials. In *Biodeterioration of Cultural Property: Proceedings of the International Conference on Biodeterioration of Cultural Property, February 20–25, 1989, Held at National Research Laboratory for Conservation of Cultural Property, in Collaboration with ICCROM and INTACH*, ed. O. P. Agrawal and Shashi Dhawan, 240–49. New Delhi: Macmillan India.

James, P. W.
1973. The effect of air pollutant other than hydrogen fluoride and sulfur dioxide on lichens. In *Air Pollution and Lichens*, 143–75. London: Athlone Press.

Jones, B.
1987. The alteration of sparry calcite crystals in a vadose setting, Grand Cayman Island. *Canadian Journal of Earth Science* 24:2292–304.

Jones, B., and G. Pemberton
1987. Experimental formation of spiky calcite through organically mediated dissolution. *Journal of Sedimentary Petrology* 57:687–94.

Jones, D., and M. J. Wilson
1985. Chemical activity of lichens on mineral surfaces: A review. *International Biodeterioration* 21:99–104.

Jones, D., M. J. Wilson, and W. J. McHardy
1981. Lichen weathering of rock-forming minerals: Application of scanning electron microscopy and microprobe analysis. *Journal of Microscopy* 124:95–104.

1987. Effects of lichens on mineral surfaces: Symposium on scientific methodologies applied to works of art. In *Biodeterioration 7: Selected Papers Presented at the Seventh International Biodeterioration Symposium, Cambridge, U.K., 6–11 September 1987*, ed. D. R. Houghton, R. N. Smith, and H. O. W. Eggins, 129–34. New York: Elsevier Applied Science.

Kauffmann, J.
1952. Role des bacteries dans l'alteration des pierres calcaires des monuments. *Comptes Rendus des Séances de l'Académie des Sciences* 234:2395–97.

Keen, R.
1976. *Controlling Algae and Other Growths on Concrete*. Advisory note 45.020. Slough, England: Cement and Concrete Association.

Keller, W. D., and A. F. Frederickson
1952. Role of plants and colloidal acids in the mechanisms of weathering. *American Journal of Science* 250:594–608.

King, L. K., and B. C. Parker
1988. A simple rapid method for enumerating total viable and metabolically active bacteria in ground water. *Applied and Environmental Microbiology* 54:1630–31.

Koestler, R. J., A. E. Charola, M. Wypyski, and J. J. Lee
1985. Microbiologically induced deterioration of dolomitic and calcitic stone as viewed by scanning electron microscopy. In *5th International Congress on Deterioration and Conservation of Stone, Proceedings, Lausanne, 25–27 September 1985*, vol. 2, comp. G. Félix, 617–626. Lausanne, Switzerland: Presses polytechniques romandes.

Koestler, R. J., and E. D. Santoro
1988. Assessment of the susceptibility to biodeterioration of selected polymers and resins. GCI Scientific Program Report, Getty Conservation Institute, Marina del Rey, Calif.

Koestler, R. J., E. D. Santoro, F. Preusser, and A. Rodarte
1987. A note on the reaction of methyl trimethoxysilane to mixed cultures of microorganisms. In *Biodeterioration Research 1*, ed. Gerald C. Llewellyn and Charles E. O'Rear, 317–21. New York: Plenum Press.

Köppen, W.
1936. Das geographische system der klimate. In *Hanbuch der Klimatologie*, vol. 1. Berlin: Borntager.

Krumbein, W. E.
1968. Inquiry on biological decomposition: The influence of microflora on the decomposition of building stone and its dependence on edaphic factors. *Zeitschrift fur Allegmeine Microbiolige* 8:107–17.

1983. *Microbial Geochemistry*. Oxford, England: Blackwell.

1987. Microbial interaction with mineral materials: Symposium on scientific methodologies applied to works of art. In *Biodeterioration 7: Selected Papers Presented at the Seventh International Biodeterioration Symposium, Cambridge, U.K., 6–11 September 1987*, ed. D. R. Houghton, R. N. Smith, and H. O. W. Eggins, 78–100. New York: Elsevier Applied Science.

[1988]. Biology of stone and minerals in buildings—biodeterioration, biotransfer, bioprotection. In *6th International Congress on Deterioration and Conservation of Stone*, vol. 2, comp. J. Ciabach, 1–12. Torun, Poland: Nicholas Copernicus University Press Department.

Krumbein, W. E., and H. J. Altmann
1973. A new method for the detection and enumeration of manganese oxidizing and reducing microorganisms. *Helgolander Wiss. Meeresunters* 25:347–56.

Krumbein, W. E., S. E. Diakumaku, C. Gehrmann, A. A. Gorbushina, G. Groti, C. Heyn, J. Kuroczkin, V. Schostak, K. Sterflinger, T. Warscheid, B. Wolf, U. Wollenzien, Y. Yun-Kyung, and K. Petersen
1996. Chemoorganotrophic microorganisms as agents in the destruction of objects of art—a summary. In *8th International Congress on Deterioration and Conservation of Stone, Berlin, 30 September–4 October 1996, Proceedings*, ed. Josef Riederer, 631–36. Berlin: n.p.

Krumbein, W. E., S. E. Diakumaku, K. Petersen, T. Warscheid, and C. Urzi
1993. Interactions of microbes with consolidants and biocides used in the conservation of rocks and mural paintings. In *Conservation of Stone and Other Materials: Proceedings of the International RILEM/Unesco Congress Held at the Unesco Headquarters, Paris, June 29–July 1, 1993*, vol. 2, ed. M.-J. Thiel, 589–96. London: E and FN Spon.

Krumbein, W. E., and M. Gross
1992. Interactions of biocides with cultures of biodeteriorating microflora in agar diffusion and rock cube test. In *Proceedings of the 7th International Congress on Deterioration and Conservation of Stone, Held in Lisbon, Portugal, 15–18 June 1992*, ed. J. Delgado Rodrigues, Fernando Henriques, and F. Telmo Jeremias, 501–9. Lisbon: Laboratório Nacional de Engenharia Civil.

Krumbein, W. E., G. Grote, and K. Petersen
1987. Metal biotransfer and biogenic crust formation in building stones. In *The Biodeterioration of Constructional Materials: Proceedings of the Summer Meeting of the Biodeterioration Society Held at TNO Division of Technology for Society, Delft, the Netherlands, 18–19 September, 1986*, ed. L. H. G. Morton, 15–27. Kew, England: Biodeterioration Society.

Krumbein, W. E., and K. Jens
1981. Biogenic rock varnishes of Negev desert (Israel), an ecological study of iron and manganese transformation by cyanobacteria and fungi. *Oecologia* 50:25–38.

Krumbein, W. E., and C. Lange
1978. Decay of plaster, painting and wall material of the interior of buildings via microbial activity. In *The Terrestrial Environment*, 687–97. Vol. 2 of Environmental Biogeochemistry and Geomicrobiology. Ann Arbor, Mich.: Ann Arbor Science.

Krumbein, W. E., K. Petersen, and H. J. Schellnhuber
1989. On the geomicrobiology of yellow, orange, red, brown and black films and crusts developing on several different types of stone and objects of art. In *Le pellicole ad ossalati: Origine e significato nella conservazione delle opere d'arte*, Centro CNR, 337–47. Milan: Gino Bozza.

Kumar, R.
1989. Science branch's physical progress reports. Internal report, Archaeological Survey of India, Bhubaneswar, India.

Kumar, R., and R. K. Sharma
1992. Conservation of deul of the Lord Jagannath temple, Puri (Orissa), India: A case study. In *Proceedings of the 7th International Congress on Deterioration and Conservation of Stone, Held in Lisbon, Portugal, 15–18 June 1992*, ed. J. Delgado Rodrigues, Fernando Henriques, and F. Telmo Jeremias, 1471–80. Lisbon: Laboratório Nacional de Engenharia Civil.

Kuroczkin, J., K. Bode, K. Petersen, and W. E. Krumbein
[1988]. Some physiological characteristics of fungi isolated from sandstones. In *6th International Congress on Deterioration and Conservation of Stone*, vol. 2, comp. J. Ciabach, 21–25. Torun, Poland: Nicholas Copernicus University Press Department.

Lal, B. B.
1962–63. Chemical preservation of ancient objects. *Ancient India* 18/19:230–50.

1970. Indian rock paintings and their preservation. *Aboriginal Antiquities in Australia* (22):139–46.

[1978]. Weathering and preservation of stone monuments under tropical conditions: Some case histories. In *Altération et protection des monuments en pierre, colloque international, Paris, du 5 au 9 juin 1978/Deterioration and Protection of Stone Monuments, International Symposium, Paris, June 5–9 1978*, pt. 7.8. [Paris: Unesco-RILEM.]

Lallemant, R., and S. Deruelle
[1978]. Presence de lichens sur les monuments en pierre: Nuisance ou protection. In *Altération et protection des monuments en pierre, colloque international, Paris, du 5 au 9 juin 1978/Deterioration and Protection of Stone Monuments, International Symposium, Paris, June 5–9 1978*, pt. 4.6. [Paris: Unesco-RILEM.]

Lazzarini, L., and O. Salvadori
1989. A reassessment of the formation of the patina called scialbatura. *Studies in Conservation* 34:20–26.

Lee, K. B., and Y. C. Wee
1982. Algae growing on walls around Singapore. *Malayan Nature Journal* 35:125–32.

Lepidi, A. A., and G. Schippa
1973. Some aspects of the growth of chemotrophic and heterotrophic microorganisms on calcareous surfaces. In *Colloque international sur la détérioration des pierres en oeuvre, 1er, La Rochelle, 11–16 septembre 1972*, 143–48. Chambéry, France: Les imprimeries réunies de Chambéry.

Levitt, J.
1972. *Response of Plants to Environmental Stresses*. New York: Academic Press.

Lewis, F. J., E. May, B. Daley, and A. F. Bravery
1987. The role of heterotrophic bacteria in the decay of sandstone from ancient monuments. In *The Biodeterioration of Constructional Materials: Proceedings of the Summer Meeting of the Biodeterioration Society Held at TNO Division of Technology for Society, Delft, the Netherlands, 18–19 September, 1986*, ed. L. H. G. Morton, 45–53. Kew, England: Biodeterioration Society.

Lewis, F. J., E. May, and A. F. Bravery
1988. Metabolic activities of bacteria isolated from building stone and their relationship to stone decay. In *Biodeterioration 7: Selected Papers Presented at the Seventh International Biodeterioration Symposium, Cambridge, U.K., 6–11 September 1987*, ed. D. R. Houghton, R. N. Smith, and H. O. W. Eggins, 107–12. New York: Elsevier Applied Science.

Lewis, F. J., E. May, and R. Greenwood
[1988]. A laboratory method for assessing the potential of bacteria to cause decay of building stone. In *6th International Congress on Deterioration and Conservation of Stone*, vol. 2, comp. J. Ciabach, 48–58. Torun, Poland: Nicholas Copernicus University Press Department.

Leznicka, S.
1992. Antimicrobial protection of stone monuments with p-hydroxybenzoic acid esters and silicon resin. In *Proceedings of the 7th International Congress on Deterioration and Conservation of Stone, Held in Lisbon, Portugal, 15–18 June 1992*, ed. J. Delgado Rodrigues, Fernando Henriques, and F. Telmo Jeremias, 481–90. Lisbon: Laboratório Nacional de Engenharia Civil.

Leznicka, S., J. Kuroczkin, W. E. Krumbein, A. Strzelczyk, and K. Petersen
1991. Studies on the growth of selected fungal strains on limestones impregnated with silicone resins. In *International Biodeterioration* 28:91–111.

Lisi, S., A. M. Ricco, M. Zagari, and C. Urzi
1992. On the efficiency of biocides against biodegradative fungal strains isolated from rock using the contact time technique. In *Proceedings of the 7th International Congress on Deterioration and Conservation of Stone, Held in Lisbon, Portugal, 15–18 June 1992*, ed. J. Delgado Rodrigues, Fernando Henriques, and F. Telmo Jeremias, 453–57. Lisbon: Laboratório Nacional de Engenharia Civil.

Lloyd, A. O.
1972. An approach to the testing of lichen inhibitors. In *Biodeterioration of Materials: Proceedings of the 2nd International Biodeterioration Symposium, Lunteren, the Netherlands, 13–18 September 1971*, ed. A. Harry Walters and E. H. Hueck–van der Plas, 185–91. London: Applied Science.

Mamonova, I. V., E. P. Melnikova, M. V. Solovsky, E. F. Panarin, N. A. Zaikina, and V. V. Gromov
[1988]. Catapol, a new polymer in restoration. In *6th International Congress on Deterioration and Conservation of Stone*, vol. 2, comp. J. Ciabach, 262–67. Torun, Poland: Nicholas Copernicus University Press Department.

Martin, A. K., and G. C. Johnson
1992. Chemical control of lichen growths established on building materials: A compilation of the published literature. *Biodeterioration Abstracts* 2(6):101–17.

Martin, M. A. E., ed.
1985. *Concise Dictionary of Biology*. Oxford: Oxford University Press.

Martines, G. G.
1983. Marmo e restauro dei monumenti antichi: Estetica delle rovine, degrado delle strutture all'aperto, un'ipotesi di lavoro. In *Marmo Restauro—Situazioni e Prospettive: Atti del convegno, Carrara, 31 maggio 1983*, ed. Enrico Dolci, 83–92. Carrara, Italy: Internazionale Marmi e Macchine.

Martinez, P., J. Castro, and A. Sanchez
1993. The biodeterioration of cultural property of Cuba. In *Recent Advances in Biodeterioration and Biodegradation*, vol. 1, ed. K. L. Garg, Neelima Garg, and K. G. Mukerji, 379–97. Calcutta: Naya Prokash.

Mathur, M. S.
1983–84. Biological growth on archaeological monuments: Its effects on animal life. *Conservation of Cultural Property in India (IASC)* (16/17):26–28.

May, E., and F. J. Lewis
[1988]. Strategies and techniques for the study of bacterial populations on decaying stonework. In *6th International Congress on Deterioration and Conservation of Stone*, vol. 2, comp. J. Ciabach, 59–70. Torun, Poland: Nicholas Copernicus University Press Department.

May, E., F. J. Lewis, S. Pereira, S. Tayler, M. R. D. Seaward, and D. Allsopp
1993. Microbial deterioration of building stone: A review. *Biodeterioration Abstracts* 7(2):109–23.

Meincke, M., B. Ahlers, T. Krause-Kupsch, E. Krieg, C. Meyer, F. Sameluck, W. Sand, B. Wolters, and E. Bock
[1988]. Isolation and characterization of endolithic nitrifiers. In *6th International Congress on Deterioration and Conservation of Stone*, vol. 1, comp. J. Ciabach, 15–23. Torun, Poland: Nicholas Copernicus University Press Department.

Meyer, R. E., and R. W. Bovey
1973. Control of woody plants with herbicides mixtures. *Weed Science* 21:448–51.

Mink, J. F.
1983. Groundwater hydrology in agriculture in the humid tropics. In *Hydrology of the Humid Tropical Regions with Particular Reference to the Hydrological Effects of Agriculture and Forestry Practice*, 140. London: Wiley.

Mishra, A. K., K. L. Garg, K. K. Jain, G. Kamlakar, and V. P. Rao
1995. Microbiological deterioration of stone: An overview. In *Conservation, Preservation and Restoration: Traditions, Trends and Techniques*, ed. G. Kamlakar and V. Pandit Rao, 217–28. Hyderabad, India: Birla Archeological and Cultural Research Institute.

Mishra, A. K., K. K. Jain, and K. L. Garg
1995. Role of higher plants in the deterioration of historic buildings. *The Science of the Total Environment* 167:375–92.

Monte, M.
1991. Multivariate analysis applied the conservation of monuments: Lichens on the Roman Aqueduct Anio Vetus in S. Gregorio. *International Biodeterioration* 28:151–63.

Monte Sila, M., and G. Tarantino
1981. The metabolic state of microorganisms of the genus *Thiobacillus* on stone monuments. In *Conservation of Stone 2: Preprints of the Contributions to the International Symposium, Bologna, 27–30 October 1981*, ed. Raffaella Rossi-Manaresi, 117–27. Bologna: Centro per la conservazione delle sculture all'aperto.

Mortland, M. M., K. Lawton, and G. Uehara
1956. Alteration of biotite to vermiculite by plant growth. *Journal of Soil Science* 82:477–81.

Nagpal, I. C.
1974. Surface preservation and monuments—my experience. In *Conservation in the Tropics: Proceedings of the Asia-Pacific Seminar on Conservation of Cultural Property, February 7–16, 1972, Held at the Central Conservation Laboratory, National Museum, New Delhi*, ed. O. P. Agrawal, 125–30. Rome: International Centre for the Preservation and Restoration of Cultural Property.

Nieoboer, E., D. H. S. Richardson, K. J. Puckett, and F. D. Tomassini
1976. The phytotoxicity of sulfur dioxide in relation to measurable responses in lichens. In *Effects of Air Pollution on Plants*, 9–14. Cambridge: Cambridge University Press.

Nishiura, T., and T. Ebisawa
1992. Conservation of carved natural stone under extremely severe conditions on the top of an high mountain. In *Proceedings of the 2nd International Conference on Biodeterioration of Cultural Property, October 5–8, 1992, Held at Pacifico Yokohama*, ed. K. Toishi, H. Arai, T. Kenjo, and K. Yamano, 506–11. Tokyo: International Communications Specialists.

Nugari, M. P., M. S. D'Urbano, and O. Salvadori
1993. Test methods for comparative evaluation of biocide treatments. In *Conservation of Stone and Other Materials: Proceedings of the International RILEM/Unesco Congress Held at the Unesco Headquarters, Paris, June 29–July 1, 1993*, vol. 2, ed. M.-J. Thiel, 565–72. London: E and FN Spon.

Nugari, M. P., P. Pallecchi, and D. Pinna
1993. Methodological evaluation of biocidal interference with stone minerals—preliminary tests. In *Conservation of Stone and Other Materials: Proceedings of the International RILEM/Unesco Congress Held at the Unesco Headquarters, Paris, June 29–July 1, 1993*, vol. 2, ed. M.-J. Thiel, 295–302. London: E and FN Spon.

Nugari, M. P., and G. F. Priori
1985. Resistance of acrylic polymers (Paraloid B-72, Primal AC 33) to microorganism—first part. In *5th International Congress on Deterioration and Conservation of Stone, Proceedings, Lausanne, 25–27 September 1985*, vol. 2, comp. G. Félix, 685–93. Lausanne, Switzerland: Presses polytechniques romandes.

Orial, G., and A. Brunet
1992. Elne: The old cathedral cloister—the capitals up against a bacterial attack. In *The Conservation of Monuments in the Mediterranean Basin: Proceedings of the 2nd International Symposium*, ed. Danielle Decrouez, Jacques Chamay, and Fulvio Zezza, 237–45. Geneva: Musée d'Art et d'Histoire and Muséum d'Histoire Naturelle.

Ortega-Calvo, J. J., M. Hernandez-Marine, and C. Saiz-Jimenez
1993. Cyanobacteria and algae on historic building and monuments. In *Recent Advances in Biodeterioration and Biodegradation*, vol. 1, ed. K. L. Garg, Neelima Garg, and K. G. Mukerji, 173–203. Calcutta: Naya Prokash.

Pallecchi, P., and D. Pinna
[1988] Alteration of stone caused by lichen growth in the Roman Theater of Fiesole (Firenze). In *6th International Congress on Deterioration and Conservation of Stone*, vol. 2, comp. J. Ciabach, 39–47. Torun, Poland: Nicholas Copernicus University Press Department.

Peevy, F. A.
1972a. How to kill hardwoods by injection. *Weeds Today* (winter):8–9.

1972b. Injection treatment for killing bottomland hardwoods. *Weed Science* 20:566–68.

Petersen, K., J. Kuroczkin, A. B. Strzelczyk, and W. E. Krumbein
1988. Distribution and effects of fungi on and in sandstone. In *Biodeterioration 7: Selected Papers Presented at the Seventh International Biodeterioration Symposium, Cambridge, U.K., 6–11 September 1987*, ed. D. R. Houghton, R. N. Smith, and H. O. W. Eggins, 123–28. New York: Elsevier Applied Science.

Petersen, K., G. Grote, and W. E. Krumbein
[1988]. Biotransfer of metals by fungi isolated from rock. In *6th International Congress on Deterioration and Conservation of Stone*, vol. 2, comp. J. Ciabach, 111–19. Torun, Poland: Nicholas Copernicus University Press Department.

Pietrini, A. M., S. Ricci, M. Bartolini, and M. R. Giuliani
1985. A reddish alteration caused by algae on stoneworks: Preliminary studies. In *5th International Congress on Deterioration and Conservation of Stone, Proceedings, Lausanne, 25–27 September 1985*, vol. 2, comp. G. Félix, 653–62. Lausanne, Switzerland: Presses polytechniques romandes.

Plenderleith, H. J.
1968. Problems in the preservation of monuments. In *The Conservation of Cultural Property, with Special Reference to Tropical Conditions*, 124–34. Paris: Unesco.

Pochon, J., and C. Jaton
1967. The role of microbiological agencies in the deterioration of stone. *Chemistry and Industry* 9:1587–89.

1968. Facteurs biologiques de l'altération des pierres. In *Biodeterioration of Materials*, ed. A. Harry Walters and John J. Elphick, 258–68. Amsterdam: Elsevier.

Price, C. A.
1975. The decay and preservation of natural building stone. *Building Research Establishment Current Paper* 89:1–6.

Purvis, O. W.
1984. The occurrence of copper oxalate in lichens growing on sulphide-bearing rocks in Scandinavia. *Lichenologist* 16:197–204.

Purvis, O. W., O. L. Gilbert, and P. W. James
1985. The influence of copper mineralization on *Acarospora smaragdula*. *Lichenologist* 17(1):111–14.

Quinn, J. P.
1984. The modification and evaluation of some cytochemical techniques for the enumeration of metabolically active heterotrophic bacteria in the aquatic environment. *Journal of Applied Bacteriology* 57:51–57.

Ramchandran, T. N.
1953. Preservation of monuments. *Ancient India* 9:170–98.

Rao, D. N., and F. Le Blanc
1966. Effects of sulfur dioxide on lichen, algae with special reference to chlorophyll. *Bryologist* 70:141–57.

Reading, A. J., R. D. Thompson, and A. C. Millington
1995. *Humid Tropical Environments*. Cambridge, England: Blackwell.

Realini, M., C. Sorlini, and M. Bassi
1985. The Certosa of Pavia, a case of biodeterioration. In *5th International Congress on Deterioration and Conservation of Stone, Proceedings, Lausanne, 25–27 September 1985*, vol. 2, comp. G. Félix, 627–29. Lausanne, Switzerland: Presses polytechniques romandes.

Richardson, B. A.
1973a. Control of biological growths. *Stone Industries* 8:1–6.

1973b. Algae, lichens, mosses: What they are and what they do. *Building Maintenance* 7(3):29, 31.

1976. Control of moss, lichen and algae on stone. In *Conservation of Stone 1: Proceedings of the International Symposium, Bologna, June 19–21, 1975*, ed. R. Rossi-Manaresi, 225–31. Bologna: Centro per la conservazione delle sculture all'aperto.

1988. Control of microbial growth on stone and concrete. In *Biodeterioration 7: Selected Papers Presented at the Seventh International Biodeterioration Symposium, Cambridge, U.K., 6–11 September 1987*, ed. D. R. Houghton, R. N. Smith, and H. O. W. Eggins, 101–6. New York: Elsevier Applied Science.

Riederer, J.
1981. The preservation of historical monuments in Sri Lanka. In *Conservation of Stone 2: Preprints of the Contributions to the International Symposium, Bologna, 27–30 October 1981*, ed. Raffaella Rossi-Manaresi, 737–58. Bologna: Centro per la conservazione delle sculture all'aperto.

1984. The restoration of archaeological monuments in the tropical climate. In *ICOM Committee for Conservation 7th Triennial Meeting, Copenhagen, 10–14 September 1984 Preprints*, 84.10.21–22. Paris: ICOM Committee for Conservation.

Robins, R. J., D. O. Hall, D. J. Shi, R. J. Turner, and M. J. C. Rhodes
1986. Mucilage acts to adhere cyanobacteria and cultured plant cells to biological and inert surfaces. *Microbiology Letters* 34:155–60.

Round, F. E.
1966. *The Biology of Algae*. London: Edward Arnold.

Sadirin, H.
[1988]. The deterioration and conservation of stone historical monuments in Indonesia. In *6th International Congress on Deterioration and Conservation of Stone*, vol. 1, comp. J. Ciabach, 722–31. Torun, Poland: Nicholas Copernicus University Press Department.

Saiz-Jimenez, C.
1984. Weathering and colonization of limestones in an urban environment. *Soil Biology and Conservation of the Biosphere*, vol. 2, 757–67. Budapest: Akadémiai Kiadó.

1994. Biodeterioration of stone in historic buildings and monuments. In *Biodeterioration Research 4: Mycotoxins, Wood Decay, Plant Stress, Biocorrosion, and General Biodeterioration*, ed. Gerald C. Llewellyn, William V. Dashek, and Charles E. O'Rear, 586–604. New York: Plenum Press.

Salle, A. J.
1977. Heavy metals other than mercury and silver. In *Disinfection, Sterilization and Preservation*, ed. S. S. Block, 408. Philadelphia: Lea and Febiger.

Salvadori, O., and M. P. Nugari
1988. The effect of microbial growth on synthetic polymers used in works of art. In *Biodeterioration 7: Selected Papers Presented at the Seventh International Biodeterioration Symposium, Cambridge, U.K., 6–11 September 1987*, ed. D. R. Houghton, R. N. Smith, and H. O. W. Eggins, 424–27. New York: Elsevier Applied Science.

Salvadori, O., and A. Zitelli
1981. Monohydrate and dihydrate calcium oxalate in living lichen encrustations biodeterioration marble columns of the Basilica of Santa Maria Assunta on the island of Torcello (Venice). In *Conservation of Stone 2: Preprints of the Contributions to the International Symposium, Bologna, 27–30 October 1981*, ed. Raffaella Rossi-Manaresi, 379–90. Bologna: Centro per la conservazione delle sculture all'aperto.

Santoro, E. D., and R. J. Koestler
1991. A methodology for biodeterioration testing of polymers and resins. In *International Biodeterioration* 28:81–90.

Saxena, V. K., K. K. Jain, and T. Singh
1991. Mechanisms of biologically induced damage to stone materials. In *Biodeterioration of Cultural Property: Proceedings of the International Conference on Biodeterioration of Cultural Property, February 20–25, 1989, Held at National Research Laboratory for Conservation of Cultural Property, in Collaboration with ICCROM and INTACH*, ed. O. P. Agrawal and Shashi Dhawan, 249–58. New Delhi: Macmillan India.

Schaffer, R. J.
1972. *The Weathering of Natural Building Stones*. Building Research Special Report, no. 18. London: Her Majesty's Stationery Office.

Schnurer, J., and T. Rosswall
1982. Fluorescein diacetate hydrolysis as a measure of total microbial activity in soil and litter. *Applied and Environmental Microbiology* 43:1256–61.

Seaward, M. R. D.
1974. Some observations on heavy metal toxicity and tolerance in lichens. *Lichenologist* 6:158–64.

1988. Lichen damage to ancient monuments: A case study. *Lichenologist* 10(3):291–95.

Seaward, M. R. D., C. Giacobini, M. R. Giuliani, and A. Roccardi
1989. The role of lichens in the biodeterioration of ancient monuments with particular reference to central Italy. *International Biodeterioration* 25:49–55.

Sengupta, R.
1979. Protecting our stone monuments. *Science Reports* (April):230–36.

Seshadri, T. R., and S. S. Subramanian
1949. A lichen (*Parmelia tinctorum*) on a Java monument. *Journal of Scientific and Industrial Research* B8:170–71.

Shah, R. P., and N. R. Shah
1992–93. Growth of plants on monuments. *Studies in Museology* 26:29–34.

Sharma, B. R. N.
[1978]. Stone decay in tropical conditions: Treatment of monuments at Khajuraho M. P. India. In *Altération et protection des monuments en pierre, colloque international/Deterioration and Protection of Stone Monuments, International Symposium, Paris, 5–9 juin 1978*, pt. 7.19. [Paris: Unesco-RILEM.]

Sharma, B. R. N., K. Chaturvedi, N. K. Samadhia, and P. N. Tailor
1985. Biological growth removal and comparative effectiveness of fungicides from central India temples for a decade in-situ. In *5th International Congress on Deterioration and Conservation of Stone, Proceedings, Lausanne, 25–27 September 1985*, vol. 2, comp. G. Félix, 675–83. Lausanne, Switzerland: Presses polytechniques romandes.

Sharma, R. K., R. Kumar, and M. K. Sarkar
1989. Deplastering and conservation of Surya Narayan temple in the Lord Jagannath temple complex, Puri (Orissa). *Conservation of Cultural Property in India* (IASC) 22:79–86.

Shephard, K. L.
1987. Evaporation of water from the mucilage of a gelatinous algal community. *British Phycological Journal* 22:181–85.

Sieburth, J. M.
1975. *Microbial Seascapes: A Pictorial Essay on Marine Microorganisms and Their Environments*. Baltimore: University Park Press.

Silverman, M. P., and E. F. Munoz
1970. Fungal attack on rock: Solubilization and altered infrared spectra. *Science* 169:985–87.

Singh, A., and G. P. Sinha
1993. Corrosion of natural and monument stone with special reference to lichen activity. *Recent Advances in Biodeterioration and Biodegradation* 1:355–77.

Singh, A., and D. K. Upreti
1991. Lichen flora of Lucknow with special reference to its historical monuments. In *Biodeterioration of Cultural Property: Proceedings of the International Conference on Biodeterioration of Cultural Property, February 20–25, 1989, Held at National Research Laboratory for Conservation of Cultural Property, in Collaboration with ICCROM and INTACH*, ed. O. P. Agrawal and Shashi Dhawan, 219–31. New Delhi: Macmillan India.

Singh, T., K. K. Jain, and O. P. Agrawal
[1988]. Studies on white coral stone and problems of its conservation. In *6th International Congress on Deterioration and Conservation of Stone*, vol. 1, comp. J. Ciabach, 125–31. Torun, Poland: Nicholas Copernicus University Press Department.

Siswowiyanto, S.
1981. How to control the organic growth on Borobudur stones after the restoration. In *Conservation of Stone 2: Preprints of the Contributions to the International Symposium, Bologna, 27–30 October 1981*, ed. Raffaella Rossi-Manaresi, 759–68. Bologna: Centro per la conservazione delle sculture all'aperto.

Sneyers, R. V., and P. J. Henau
1968. The conservation of stone. In *The Conservation of Cultural Property, with Special Reference to Tropical Conditions*, 209–-35. Paris: Unesco.

Spry, A. H.
1981. The conservation of masonry materials in historic buildings. AMDEL Report no. 1381, Dept. Environment South Australia.

Stanier, R. Y., M. Doudoroff, and E. A. Adelberg
1970. *The Microbial World.* New York: Prentice Hall.

Stambolov, T., and J. R. J. Van Asperen De Boer
1967. The deterioration and conservation of porous building materials in monument: A preliminary review. Report presented to ICOM Committee for Museum Laboratories, Brussels, September. Typescript.

1969. *The Deterioration and Conservation of Porous Building Materials in Monument: A Supplementary Literature Review.* Amsterdam: n.p.

Sterflinger, K.
1995. Geomicrobiological investigations on the alteration of marble monuments by dematiaceous fungi (Sanctuary of Delos, Cyclades, Greece), Ph.D. diss., University of Oldenburg, Germany.

Strzelczyk, A. B.
1981. Stone. In *Microbial Biodeterioration*, ed. A. H. Rose, 61–80. Vol. 6 of *Economic Microbiology.* London: Academic Press.

Syers, J. K., and I. K. Iskandar
1973. Pedogenic significance of lichens. *The Lichens*, ed. Vernon Ahmadjian and Mason E. Hale, 9–29. New York: Academic Press.

Tandon, B. N.
1991. Biodeterioration of Khajuraho group of temples: A scientific study and the remedial measures. In *Biodeterioration of Cultural Property: Proceedings of the International Conference on Biodeterioration of Cultural Property, February 20–25, 1989, Held at National Research Laboratory for Conservation of Cultural Property, in Collaboration with ICCROM and INTACH*, ed. O. P. Agrawal and Shashi Dhawan, 259–72. New Delhi: Macmillan India.

Tanner, H., P. Cox, P. Bridges, and J. Broadbent
1975. *Restoring Old Australian Houses and Buildings: An Architectural Guide.* Melbourne: Macmillan.

Tayler, S.
1992. Composition and activity of bacterial populations found on decaying stonework. Ph.D. diss., University of Portsmouth, United Kingdom.

Tayler, S., and E. May
1995. A comparison of methods for the measurement of microbial activity on stone. *Studies in Conservation* 40:163–70.

Tecneco
1976. *Studies for the Preservation of Monuments in Agra from Mathura Air Pollution: Third Report.* San Ippolito (Pesaro), Italy: Tecneco.

Tiano, P.
1979. Antialgal effect of some chemicals on exposed stoneworks. In *Deterioration and Preservation of Stones: Proceedings of the 3rd International Congress,* 253–60. Padua, Italy: Università degli Studi di Padova, Istituto di Chimica Industriale.

1987. Biological deterioration of exposed works of art made of stone. In The *Biodeterioration of Constructional Materials: Proceedings of the Summer Meeting of the Biodeterioration Society Held at TNO Division of Technology for Society, Delft, the Netherlands, 18–19 September, 1986,* ed. L. H. G. Morton, 37–44. Kew, England: Biodeterioration Society.

1993. Biodeterioration of stone monuments: A critical review. In *Recent Advances in Biodeterioration and Biodegradation,* vol. 1, ed. K. L. Garg, Neelima Garg, and K. G. Mukerji, 300–321. Calcutta: Naya Prokash.

Tiano, P., R. Bianchi, G. Gargani, and S. Vannucci
1975. Research on the presence of sulfur-cycle bacteria in the stone of some historical buildings in Florence. *Plant and Soil* 43:211–17.

Tiano, P., L. Tomaselli, and C. Orlando
1989. The ATP-bioluminescence method for a rapid evaluation of the microbial activity in the stone materials of monuments. *Journal of Bioluminescence and Chemiluminescence* 3:213–16.

Tricart, J.
1972. *Landforms of the Humid Tropics, Forests and Savannas.* London: Longman.

Tripathi, S. N., and E. R. S. Talpasayi
1990. Contribution of organic matter by sub-aerial cyanobacteria. *Journal of Phycology* 26:13.

Viles, H. A.
1987. Blue-green algae and terrestrial limestone weathering on Aldabra atoll: An SEM and light microscope study. *Earth Surface Processes and Landforms* 12:319–30.

Voute, C.
1969. *Indonesia: Geological and Hydrological Problems Involved in the Preservation of the Monuments of the Borobudur.* Unesco document no. 1241/BMF-RD/CLT. Paris: Unesco.

Wakefield, R. D., and M. S. Jones
1996. Some effects of masonry biocides on intact and decayed stone. In *8th International Congress on Deterioration and Conservation of Stone, Berlin, 30 September–4 October 1996, Proceedings,* ed. Josef Riederer, 703–16. Berlin: n.p.

Walker, M. B. P.
1989. *Cambridge Dictionary of Biology.* New York: Cambridge University Press.

Ware, G. W.
1978. *The Pesticide Book.* San Francisco: W. H. Freeman.

Warscheid, T.
1990. Untersuchungen zur Biodeterioration von Sandsteinen unter besonderer Berucksichtigung der chemoorganotrophen Bakterien. Ph.D. diss., University of Oldenburg, Germany.

Warscheid, T., D. Barros, T. W. Becker, S. Eliasaro, G. Grote, D. Janssen, L. Jung, S. P. B. Mascarenhas, M. L. Mazzoni, K. Petersen, E. S. Simonoes, Y. K. Moreira, and W. E. Krumbein
1992. Biodeterioration studies on soapstone, quartzite and sandstone of historical monuments in Brazil and Germany: Preliminary results and evaluation for restoration practices. In *Proceedings of the 7th International Congress on Deterioration and Conservation of Stone, Held in Lisbon, Portugal, 15–18 June 1992,* ed. J. Delgado Rodrigues, Fernando Henriques, and F. Telmo Jeremias, 491–500. Lisbon: Laboratório Nacional de Engenharia Civil.

Warscheid, T., K. Petersen, and W. E. Krumbein
1988. Effect of cleaning surfaces on the distribution of microorganisms on rock. In *Biodeterioration 7: Selected Papers Presented at the Seventh International Biodeterioration Symposium, Cambridge, U.K., 6–11 September 1987*, ed. D. R. Houghton, R. N. Smith, and H. O. W. Eggins, 455–60. New York: Elsevier Applied Science.

1990. A rapid method to demonstrate and evaluate microbial activity on decaying sandstone. *Studies in Conservation* 35:137–47.

Webley, D. M., M. E. K. Henderson, and I. F. Taylor
1963. The microbiology of rocks and weathered stone. *Journal of Soil Science* 14(1):102–12.

Wee, Y. C.
1988. Growth of algae on exterior painted masonry surfaces. *International Biodeterioration* 24(4/5):367–71.

Wee, Y. C., and K. B. Lee
1980. Proliferation of algae on surfaces of buildings in Singapore. *International Biodeterioration Bulletin* 16:113–17.

Wilderer, P.A., and W. G. Characklis
1989. Structure and function of biofilms. In *Structure and Function of Biofilms*, 5–17. Chichester, England: John Wiley and Sons.

Williams, D. E., and N. T. Coleman
1950. Cations exchange properties of plant root surfaces. *Plant and Soil* 2:243–56.

Williams, M. E., and E. D. Rudolph
1974. The role of lichens and associated fungi in chemical weathering of rock. *Mycologia* 66:648–80.

Wilson, M. J., and D. Jones
1983. Lichen weathering of minerals and implications for pedogenesis: Residual deposits. In *Surface Related Weathering Processes and Materials*, 5–12. Special publication of Geological Society. London: Blackwell.

Wilson, M. J., D. Jones, and W. J. McHardy
1981. The weathering of serpentinite by *Lecanora atra*. *Lichenologist* 13:167–76.

Winkler, E. M.
1975. Stone decay by plants and animals. In *Stone: Properties, Durabilities in Man's Environment*, 154–63. New York: Springer Verlag.

Wolters, B., W. Sand, B. Ahlers, F. Sameluck, M. Meincke, C. Meyer, T. Krause-Kupsch, and E. Bock
[1988]. Nitrification—the main source for nitrate deposition in building stones. In *6th International Congress on Deterioration and Conservation of Stone*, vol. 1, comp. J. Ciabach, 24–31. Torun, Poland: Nicholas Copernicus University Press Department.

Wright, I. C.
1986. The deterioration of paint films by algae and lichens. In *Biodeterioration 6: Papers Presented at the 6th International Biodeterioration Symposium, Washington, D.C., August 1984*, ed. Sheila Barry and D. R. Houghton, 637–43. Slough, England: CAB International Mycological Institute and The Biodeterioration Society.

Index

About the Authors

Rakesh Kumar received his Ph.D. in organic chemistry from the University of Gorakhpur, India, in 1989 and completed his postdoctoral work in 1992 at University College London. His professional activities have centered on the development and evaluation of consolidants and coatings for preservation of architectural building materials. He has worked for organizations such as the science branch of the Archaeological Survey of India; the Getty Conservation Institute, Los Angeles; and the National Center for Preservation Technology and Training, Natchitoches, Louisiana. During this time, his research was focused on new coatings and biocides for the preservation of historical building materials, particularly for application in tropical regions. Currently, he is technical director at United Panel, Inc., in Mt. Bethel, Pennsylvania, where he is working on the development and evaluation of ultraviolet-cured coatings for architectural panels.

Anuradha V. Kumar received her B. Arch. in 1989 from the Center for Environmental Planning and Technology, Ahmedabad, India; and her M. S. in Historic Preservation in 1992 from the University of Pennsylvania, Philadelphia. She has specialized in the conservation of historic masonry structures and preservation planning and, for more than eight years, has provided her services for many historically significant buildings in the United States, Central America, and the Indian subcontinent. She has worked for institutions such as the Society for Preservation of New England Antiquities, Boston; National Center for Preservation Technology and Training, Natchitoches, Louisiana; and the Getty Conservation Institute, Los Angeles. She is currently an architectural conservator at the New England Regional Office of Building Conservation Associates, Inc., in Dedham, Massachusetts.